RAJASTHAN

To Berndt Everts, my husband.

© 2003 Assouline Publishing
601 West 26th Street, 18th Floor
New York, NY 10001 USA
Tel.: 212 989-6810 Fax: 212 647-0005
www.assouline.com

© 2003 Pauline van Lynden for all the illustrations and the texts

ISBN : 2 84323 446 8

Color separation: Gravor (Switzerland)
Printing by Grafiche Milani (Italy)

Pauline van Lynden

RAJASTHAN

ASSOULINE

I saw Pauline van Lynden's book with her photographs, sketches, and notes when it was just a rough proof. Knowing of her love for Rajasthan and her extensive travels around the State, it is not at all surprising that her work gives such an intimate and colourful glimpse of Rajasthan, its people and many customs. At the same time, we are also offered the very evocative and personal view of someone with a sensitive and inquisitive eye for the unusual.

Hence, what has emerged is a very different book on Rajasthan from those we have seen so far. It makes us, particularly Indians, look afresh at what we consider to be mundane and take for granted: a deep sense of style and colour; a joie de vivre manifest in our many fairs and festivals; a respect for nature and traditional ways of living, threaded through every moment of life, providing it with a meaning and vitality. The vignettes that set India apart from other civilisations are subtly revealed through her lens.

Pauline's book, I am sure, will arouse the curiosity of many travellers to visit Rajasthan, and also rekindle the urge amongst old friends to visit again. As for us, I hope that it will awaken our awareness and help us preserve the essence of Rajasthan, the Jewel in India's crown.

H.H. Gajsingh II

Maharaja of Marwar - Jodhpur

Contents

Everyone needs a quest as an excuse for living.
Bruce Chatwin

One September evening I was sitting on a lawn in the inner courtyard of Rohet Garh, a 300-year-old fort on the edge of the Thar Desert. Outside the high walls, behind huge doors which are still shut and guarded at night, is a dusty village and a seemingly endless stretch of dry countryside towards the west and the border with Pakistan. Earlier that day, while I was concentrating on taking pictures at the silversmith, the light suddenly changed to an intense dark yellow and the air became still and eerie. I ran back to the garh, expecting heavy showers of rain. The winds came, blowing with a loud hissing sound, but not a single drop of rain fell. Two hours later, every surface was covered with fine sand; at home, the sweeping continued for a long time.

Wrapped in the blue shades of the falling night, with my notebook on my lap, I listened to the sounds of dusk: the cries of the peacocks in the neem trees overhead, the silvery sound of bells for evening service ringing at the nearby temple. I could see the priest holding the fire in his hand and moving it in circles in front of the deities. The cows had come back from grazing, running home on their own, each one knowing exactly where it belonged. Men were sitting together in starched white kurta pyjamas smoking a pipe that went from hand to hand. And from inside the houses, sparsely lit by naked bulbs, came women's voices and the smells of cooking on wood fires.

An evening like this is a time for stories, told by turbaned men in their soft, rolling tongue. My eyes would fill with colour and I would scribble at high speed in my notebooks trying not to miss a word of these tales which sounded like the beloved Contes et Légendes *of my childhood. Stories of ancient times, of love and courage, of heroes and their brave horses, camel caravans loaded with spices, jewellery and brocades. Modern anecdotes too, often with a similar flavour and accompanied by lots of laughter.*

My Rajasthan is founded on images and atmosphere. I have brought together my photographs as a collage, using them as if they were paint, to portray more forcefully what catches my eye and my soul. My hosts often have been surprised at what I photographed, wondering what could be so thrilling when I once again took a funny picture. It soon became known that "Polly Madam" was interested in everything.

I do not pretend to have covered all of Rajasthan with this book. It is a reflection of my wanderings. In this land of contrasts much is charged with the hidden rules of time and tradition, and the pages are the result of what might happen on any particular day. I have learnt to respect the unknown, and also the unexpected. There is a mystery that gives significance to the smallest and the simplest thing. To some extent, my book is about places most visitors do not have the chance to see. But above all, it is intended to show the delight I have found in a way of life which, often with very little means, results in great beauty.

Everybody in Rajasthan has a few stories of miracles which happened either to themselves or to someone close. Maybe this is how I happened to understand a piece of my own mystery, having met with another world at such places as the small roadside shrines shown at the end of this book.

P. v. L.

Introduction

Rajasthan, the land of Kings, is India's second largest state and covers about one tenth of its total surface. It is located in the arid northwest of the country, along the border with Pakistan. Its outlines were first established under the Mughal rule of Akbar in the sixteenth century, confirmed by the British and reaffirmed at the independence of India in 1947. The Aravallis, a low mountainous range, divide Rajasthan diagonally into two distinct parts, with the eastern side being relatively green and fertile, while the dry western plain is swept by the sandstorms of the Thar Desert.

Rajputana, as Rajasthan was previously named, meaning "the country of Rajputs", originally consisted of kingdoms of quite different sizes governed by the Rajput clans. Even today these smaller states can provide contrasting frames of space and culture. A certain rivalry can still be sensed. Some rulers joined the Muslim kings while others pride themselves with having never done so. The borders between Mewar and Marwar are said to be visible by the presence or the absence of a yellow-flowering Anola shrub that only grows on the Udaipur side and the straight-growing Banolia tree that is only found on Jodhpur ground.

Rajasthan's history, sung in folk songs, told in tales and found in poetry and paintings, is rich with the sounds of the battlefields, the wearing of orange turbans on the way to sacrifice, and all the passionate deeds of a proud and independent people in an extremely hostile environment. Singh, the common Rajput family name, means "as brave as a lion". Historically, Rajputs took an oath by the sword, fought until death, and when not fighting were said to have enjoyed life like the gods!

It is probably due to the difficult conditions of life in the desert that there still remains such a strong sense of tradition and a deep faith in supernatural powers. The Rajasthani people's amazing sense of colour can be seen as a natural reaction to the general atmosphere of sand and dust. Even today the people of Rajasthan have been able to keep a pronounced cultural identity which stands apart from other parts of India.

An unwritten story unfolds with the sequence of themes in this book. The connection between some pages may appear a little strange, but they are always linked by the spontaneous way in which I found my images. In general, though, the book follows my wanderings from cities to countryside and the flow of subjects that touched me as I went. A piece of coloured sacred thread binds it all together. The thread was tied around my wrist by a village priest during an impressive ceremony. Back home, I attached it to a tree in my garden where a bird patiently pulled at it and later on I found the faded fibres lining its nest.

To me, Rajasthan is visual splendour. My memories are based essentially on the surprise of the moment, and this explains why I have limited the text. I recall that my experiences began with confusion, every one of my senses triggered by overwhelming impressions of colourful people and amazing places. I wanted to remember it all. I kept asking questions and receiving contradictory answers… as polite behaviour in India requires a reply at all times! Driven by curiosity as well as a definite urge to collect, I made my way through the gateway of a fortress into the city bazaars. With my first words of Hindi, each encounter led me further as I searched for material. I was taught to recognise subtleties in textiles, I gained an appreciation for the numerous age-old crafts, and my bags, like a magician's, filled with a wild assortment of small mementoes.

After some time, a longing for quiet drove me out of the busy town, onto the road to the countryside, an old temple blessing the journey. The atmosphere can be as different from village to village as the Rajasthani cities are distinct from each other. The rural communities show their distinction in dress, adornment, even language. There are so many special moments engraved in my memory: young shepherds taking me to a local opium ceremony, my hands and feet being painted with the finest henna designs, the story of a folk hero being told for hours as stars gathered in the sky…

While staying with friends for longer periods of time I was introduced to the many festive moments of the year, when the astrological calendar determines the customs and traditions of everyday life in the form of celebrations still respected by all layers of the community. The fairs and festivals which are then organised, such as the Tilwara cattle fair, are often held in almost surreal places, and are amongst my most touching experiences.

First impressions

When I step out of my bedroom onto the balcony of a *haveli* in Bikaner, on one of my first days in Rajasthan, the sun reflects the blue and green Belgian glass of my door like a fresco on the whitewashed wall. I run back inside and grab my camera: the first picture of a rich day.

Inside that same room my suitcase is rapidly filling with gathered treasures! The happy drawing of a child used as a sachet in a designer's shop in Jaipur, a festive brushlike garland received as a welcome instead of the traditional string of marigolds; the small round mirrors and golden yarn lavishly used for embroidery on clothes by the villagers; a piece of wrapping paper, newspaper on which a print had been done by hand with blocks for textiles to make it look nicer. Soon I start collecting samples of the traditional cottons used for the swinging wide *ghagra* skirts, dark blues, greens, and reds printed by hand but now rapidly replaced by the same motifs screenprinted on synthetic material: how could women possibly wear such warm, heavy skirts in the forty or even fifty degree heat of summer?

My notebooks, almost bursting with little pieces of everything, even glued sand, have often been a way to connect with people without speaking their language: after seeing it a shopkeeper once started to cut small pieces of all the turban material he was selling, at least twenty shades of pastel colours which he proudly gave me!

My first impressions are all about colours, mostly on people: Dhala Ram, the rascal of the village, with his face pink after playing Holi, high on *bhang*; enormous turbans; a group of elderly ladies on a small road in the Shekawati, so cheerful and utterly surprised when I took their picture - what a happy and colourful way to grow old! People, like bright flowers in the sandy landscape.

In one of my notebooks, I write: "I have left Jaipur at six PM. It has been a very hot day. The railway cuts through a surprisingly green countryside. Blue bull in the mustard fields, strange sloped back. Shepherds are walking their flock (hundreds of sheep), long bamboo poles across their shoulders with sickles at the end, shining in the low sun. Grass, fields, round huts with thatched roofs. A hill with a temple on top, the sun is setting. Sky deep gold.

A small lake with white egrets. Jeeps, bullock carts and tractors gathered in chaos at railway crossings. Girls on scooters with long gloves, faces wrapped in scarves to make sure their skin will remain fair. People sit in the fields and chat, small white turbaned figures of men, bright feminine silhouettes. Sandy scenery, villages so close by. White men in starched *kurta-dhotis* under a banyan tree. Scattered *khejri* trees, green and full. Peacocks flying, pink child pumping water, bright clothes hung to dry, girls near houses. Amazing colour combinations, how can I remember them? Yellows and pinks, light green and deep purple, oranges..."

Following double pages:
❀ Door in Bikaner / child's drawing used as a sachet in a shop.
❀ My notebooks: detail of an upper-arm bracelet / collection of cottons.
❀ Bearded man at the spring festival of Holi / women in the Shekawati region.
❀ Garlands, mirrors for embroidery and other material from the bazaar.

These 3 ↑↑→,
are synthetic,
"velly"
coptenized
now by the
ladies for their
shapes—

blue knife + fish pattern
from Jaisalmeh, RS65/m

See my
Fabindia
dupparta ↑

Materials from
BALOTRA & SAMDARI
bought in Pali at
CHIMNIRAM KUMAWAT
Basi Bazar Patwa Market
(but Pokraj Roopraj, Sati's friend
seems to have them too +
cheaper)

The dark red + black = Reta (red reta + black reta)

के साथ ज्यादा का
है। विधायक दल
उन्हीं का बहुमत
जबकि सच्चाई
एकदम उलट है।
बिहार में जिस राजन
व्यक्ति की छवि
ज्यादा खराब है,
जगन्नाथ मिश्र हैं
एक आम रिक्शा
से भी बात करेंग
वह कहेगा--यह
भ्रष्ट है।

प्रतिनिधियों के हस्ताक्षरयुक्त एक
पर्यवेक्षकों को सौंप दिया, जिसग
को अधिकृत कर दिया गया है।
रायशुमारी की जरूरत नहीं समझते

मारपीट करने वाले
कौन?

वे कांग्रेस के समर्पित कार्य
जो कांग्रेस के जनता दल की
वन कर रह जाने से आहत है।

जगन्नाथ मिश्र समर्थक
आरोप है कि प्रदेश कांग्रेस
पर उस दिन रामलखनसिंह
गुंडों ने कब्जा कर लिया था

अच्छा तो फिर बताइए,
नेतृत्व प्रदेश मुखयालय को गुं
बचा सका, तो इस बात की क
कि अगले चुनाव में लालू
व्यक्ति पूरे बिहार में बूथ कैप्प्
केंद्रों पर कब्जा) नहीं कर लेगा
जिस नाटकीय ढंग से
प्रस्ताव लाया गया, उससे व
की छवि खराब नहीं हुई ?

कांग्रेस जन और विहार
चाहती थी कि कांग्रेस आक्र
की भूमिका निभाये, पर जब त

बिहार में इस समय प्र
संगठन में परिवर्तन की ब
वह कितनी आवश्यक है ?

वह परिस्थिति के हिसाब
था नहीं। लेकिन यह कार्य सि
हुआ। कांग्रेस अध्यक्ष को यह
किया गया, जहां उचित समझेंगे
उसकी अनुशंसा के अनुसार
वहां दल गया। बातचीत क
मुखालफत कर रहे हैं, जिनका
कमिटी में समर्थन नहीं है, उन्होंने
करायी, पर पर्यवेक्षक दल से
80 प्रतिशत लोग हिदायतुल्ल
में थे। 472 लोगों ने हस्ताक्षर

Forts and cities

Crenellated walls creeping over hills like the Great Wall of China: one can see Rajasthan's old forts from a long distance. Golden Jaisalmer, sticking out of the sand, last station before the desert's no man's land, where dunes bury asphalt roads. Fierce Chittorgarh, impregnated with the memory of battles and sacrifice. Kumbalgarh, now lush and green, scattered ruins of carved temples and water wells surrounded by thirty-odd kilometers of thick walls. On the rocks of Jodhpur's impressive Mehrangarh fort, its fearsome mass towering over the countryside, colonies of fierce-looking vultures watch over red sandstone palaces and blue houses. The main towns of Rajasthan grew out of fortified palaces. All of them can be protected from the world outside by tall heavy doors covered with sharp iron spikes. Assaillants on elephants' backs would have hesitated before trying to force them.

Despite the ever-present brutality of life, great care has been taken to embellish any building even on its defensive side, and violence is balanced with extraordinary refinement. The "Elephant gate" in Bundi illustrates this well: its last set of sturdy doors, on top of a steep climb, opens to lush inner courtyards of the palace. In times of peace musicians would sit on the outer balconies, playing for the welcome guests. While they were rocked by the gait of the for-now gentle elephants, reclining in the padded seats of gilt *howdahs*, showers of fragrant flower petals would fall over them in a colourful rain.

I have the chance to visit Barmer, one of the most remote forts of Rajasthan. It is a long drive, and I need special permits to visit most of the surrounding areas. Not many tourists ever go there. I have been invited by the Raja of Barmer, Rawal Umaid Singh Rathore, who leads a frugal life in what remains of a palace overlooking the city. Cows sit in the courtyard but among the ruins, red sandstone carvings testify to a prosperous past. The Rajputs were great builders, and Rajput courts have been important centres for the arts. I walk up a good many steps but, as promised, am richly rewarded at night when the lights in the houses downtown seem to reflect the huge cupola of stars above us. After dinner, sitting on the white-sheeted floors of a bright green room under the churning wings of the fan, we discuss the problems of water management in this "land of death"

as it is sometimes called, and the vanishing sense of responsibility of the communities.

"A Pink City"; Jaipur, the capital city of Rajasthan, is known by that name. It was planned by an enlightened ruler in the eighteenth century, Jai Singh II, who was inspired both by European maps found in an atlas he loved and by intensive contacts with Western Europe. Nehru said of him: "Jai Singh would have been a remarkable man anywhere and at any time." Meant to become a shelter for artisans working for a wealthy court, the large town, surrounded by high walls, follows a regular grid with areas still occupied by the same professions as when they were invited to establish themselves here three centuries ago. The streets are wide and were named after the nobles who had been given houses by their king. I find the painted portrait of such a gentleman in a small antique shop whose owner invites me to share lunch on his flat rooftop. On the unusual red and blue background, the split beard and neatly tied turban look very authentic and local to me. However, later that day when I excitedly show my latest acquisition to my hosts, they discard him with a shrug as probably "imported" from neighbouring and rival Marwar, i.e. Jodhpur!

The facades in the town are all painted with the same pigment, a locally produced burnt sienna, called *gehru*. Mixed with white, it gives an elegant softness to the whole city in an endless array of pinkish ochres. The backs of the houses, around inner courtyards, have an unexpected medieval feeling. The contrast is intense. Sounds of the bustling town are muted. This is village-Rajasthan, human scale behind urban grandeur.

Crossing the road in Jaipur can be hazardous, not only during rush hour; the overcrowded pavements are a riot of people selling metal pieces, spare parts, keys, perfumes, flowers, sweets, fruit and vegetables. Cobblers sell the famous soft Jaipuri version of Rajasthani shoes, haggling shoppers sit down next to overflowing baskets, not to mention the many tourists. The roadside advertisements add to the distraction: 'X-plain school', 'Sure success study centre', 'Whatever the passion, there is only one', and my favourite, often seen in public places: 'Inconvenience is regretted, thank you!'

Brahmpuri, Jodhpur's old heart; the houses are painted so blue that at times one feels as if one is walking under water. The different explanations are confusing but I am told that these used to be Brahmins' quarters, and traditionally Brahma is associated with the colour blue.

Built on the steps leading to the fort, the old town is full of picturesque details: green doors, household sounds coming from hidden courtyards, men playing the traditional *ganji fa* cards in the shade, a cow on a staircase and a ram with huge curled horns looking down on me from a high terrace … My guide takes me to his mother's house for a cup of sweet coffee under the walls of the fort, just below the water reservoir. A meal is being prepared on a fire in the dark kitchen area, where daylight seems to penetrate only through a slit in the ceiling; flat breads are drying on the hot stones of the roof. Accompanied with smiles and curious glances, an impossible conversation with my hostess is translated for me from Marvari Rajasthani to Hindi to pidgin English. My first words of the local language!

Surrounded by lakes, Udaipur is surprisingly white and lush amidst so much dry countryside. The steps of the *ghats*, the washing and bathing places near the water, have inspired generations of painters, particularly in the early morning and at the end of the day when they are crowded with colourful people doing their laundry or lost in prayers. Lake palaces such as the now-famous hotel on the Pichola lake, host to James Bond at one time (in *Octopussy*), or the Jal Mahal near Amber, were much loved by refined courts as a retreat during the hottest periods of the year. So were the summer apartments of many forts, often called Badal Mahal, "palace of the clouds". High up in the Udaipur City palace, at what feels like the top of a skyscraper, there is a garden complete with trees and water basins. In the Junagarh Fort of Bikaner, the walls of the apartments at roof level are covered with the bright colours of monsoon scenes, white clouds on blue skies, flying birds and poetic lightning.

Rajasthan has its own traditional ways of handling the torridity of summers. The architecture of the haveli houses allows the heat of the day to rise out of the inner courtyards and the fresh night air to flow in through a clever system of natural air-conditioning. Old inside walls are often coated with a gleaming *araish*, a highly polished stucco which feels cool like marble and contains such surprising ingredients as egg white and sugar. Swings replace static seats, and there is a vast knowledge regarding special colours to be worn and food and spices to cool the body.

The best place to escape from the heat must have been the *baolis*. Pronounced "baodis", these are often very ancient water places which can be found in even the smallest villages of the Aravalli mountains. Called "step-wells" or "lateral steps" in English, they carry lovely names like

Rani-ki-Baoli and Baiji-ka-Talab. The seven-hundred-year-old Tapi Baoli in Jodhpur has a seemingly endless staircase cut out of the same soft, sand-coloured *ghattu* stone as the palaces. The sides of the nineteenth-century *Kund* in Bundi form a rectangle covered with a network of steps. Essential for water storage until independence, they are now sadly neglected. But I can imagine the colours on the people spending lazy hours in good company on the covered terraces. Lavishly decorated with stone carvings, the levels go deep into the ground. Religious subjects and statues of Hindu gods enhance the forgotten sacredness of water.

Looking sometimes a little lost in the recesses of busy bazaar streets over which pieces of jute or cotton are stretched for shade, small shrines are more alive than one would think. People passing by make a quick gesture of respect, or sit and pray for a brief moment of total concentration. What first looked like a hole in a green wall of old Bikaner proves to be lit by a small oil lamp; the shape, vermillion paint and silver stand for Hanuman, the monkey god. I watch from a distance, touched by the chanting of a young woman while she lights incense cones and sticks a thin strand of sacred thread in the freshly painted colour. The noisy chaos of the street behind her does not seem to disturb her at all. It takes only a few minutes before she bows deep, palms joined before her heart and face, picks up her bundle and walks away.

Following double pages:
❀ Vultures and citadel walls.
❀ Entrance doors to forts adorned with iron spikes against soldiers attacking on elephants.
❀ Barmer Fort, the old ruined palace.
❀ Jaipur back and front / miniature painting of a gentleman.
❀ City street scenes.
❀ Blue Brahmpuri, the old town in Jodhpur.
❀ Udaipur, the city on lakes.
❀ Step-wells in Bundi and Jodhpur.
❀ A small shrine to Hanuman in a wall of the Bikaner bazaar / a street in Pali.

The world of women

Lunch is served in the colourful surroundings of an old *haveli*. The classical mansion was built around several courtyards. With its balconies, small windows, and constant imperceptible breeze, the whole architecture is aimed at protection from the extremes of the climate as well as from the outside world. Following the traditions of centuries, only one part of the house is for receiving guests. An outsider would only rarely visit the inner courtyards where the women lived. In palaces like Jodhpur's Mehrangarh fort, the stone *jalis*, as the screened windows are called, enabled the ladies in the past to watch outside without being seen. The slightly perceptible movements, muted voices and laughter, which I imagine went on behind these screens and curtains, must have given the *zenana* quarters an aura of irresistible mystery. Even in the twenty-first century, some Rajput women stay mainly inside their houses, cover their faces in the presence of strangers and do not speak any English. The men of the family eat together, women and children sit in another part of the room and the eldest lady will have her meal only when everybody has finished. Unlike the daughters of the house, daughters-in-law keep themselves covered constantly. This is what remains of purdah. Introduced long ago by the Muslim invaders, the custom was adopted to protect women from these very occupiers. It remains a traditional society where the modern world is only just beginning to show its face. But being a woman always put me at an advantage when taking photographs: for me, the sari is not pulled in front of the face, a smile is exchanged, curiosity defies cultured reticence, a hand stretches out to touch and estimate my jewellery.

The sound of drums draws me to one of an old palace's coloured windows: accompanied by music in a street far below, a wedding procession is approaching. It is the boys' party on their way to the bride. Seated on a caparisoned horse, his face covered by garlands of finely strung flowers and shells, he is preceded by the girls of the family dancing and cheering. Endless wedding rituals alternate with festivities. It is an occasion to meet with friends and relatives, and often to arrange other marriages! Guests come for many days, and cooking is done on open fires in huge welded metal pans, sometimes meters wide. It is not uncommon to have hundreds of people at every meal. After days of celebrations within each party's family, the final function is now soon to take place.

The girl is still hidden from sight. Surrounded by her friends and the women of her family, she is waiting in her house. Dressed and covered in the embroidered *poshak* and the jewels given, as tradition dictates, by her in-laws, she can hardly move under the weight and the growing tension.

Stepping out of the train from Delhi in our nondescript travelling clothes we are received on the platform of Jodhpur station by a batallion of men in black coats and rainbow-coloured turbans with long trails on the back. One leaves modern times within an instant. This is a royal wedding, and a rare gathering of maharajas. I have arrived in Jodhpur for six days of functions in the middle of the *Bana* ceremony, held in the palace of the bridegroom, prince Raghavendra Singh Rathore. It is the only function which will be taking place during the day. Soft light is diffused by the canopy shading the first courtyard of the palace from the scorching sun. Clouds of pastel colours surround me: seated on white *gaddi* mattresses and thick bolsters around the sacred fire, women in saris and *poshaks* chat continuously. The groom, his face covered with yellow turmeric paste, patiently endures the proceedings. In the background, singers commemorate the proud deeds of the family's history. Priests busy themselves for hours with the intricate rituals, involving several members of the family. Offers of coconuts, rose petals, sweets and fruit are performed in a mysterious sequence. Nobody seems to mind the incessant walking and talking of the guests. A room close by has been transformed into Aladdin's cave, the floor covered with presents wrapped in glossy paper. Antique dresses, tiny embroidered shoes, crimson velvet jewellery boxes…

All the women close to the family come together for the *mehendi* the next day: hands, even ankles and feet, are decorated by specialists with henna during the party. Glass bangles and saris are chosen for the wedding day. In the middle of all the bustle, the bride has to sit idle for a very long time, fed by her friends, while hands, arms and feet up to the knees are slowly being covered with drawings so fine that one can see peacocks and all kinds of details of the marriage procession.

The *mehendi* is not only for weddings but before any festive occasion. Once I was called back by the guard at a temple telling me to remove my footwear. The friend with whom I was staying at the time had insisted that their local *mehendi* artists were the best and had organised for my feet and ankles to be done. Thus, covered as they were with a fine web of patiently drawn, curly and very dark lines, the guard had mistaken the decoration for shoes. Henna is a powder of crushed dried leaves that grow on a low bush. The henna, or *mehendi*, from Rajasthan is famous for its dark colour.

There is a saying that the darker it comes out on the skin, the more one is loved by one's husband! The designs, the beauty of the beloved's palms, and love in general, are celebrated in what are known as traditional "*mehendi* songs" that girls sing while waiting for the paste to dry on their skin.

Huge excitement at the end of six days of rituals: late at night a long procession is formed, ready to leave the prince's palace in the darkness. Accompanied by fireworks and lots of noise, at least fifty jeeps drive through the dark streets, full of multicoloured turbans on cheering heads. Then come the elephants, camels, horses, and the royal palanquin in which the young princess is to be carried to her new house. At last, the glittering lines of maharajas precede the young prince on his caparisoned horse. He is wearing the embroidered wedding gear of his grandfather, all silver and gold thread, bejewelled sword and glittering stones. A line of similarly elegant men in sparkling outfits stand ready on the girl's side, looking impassive but waiting with growing nervousness to exchange flower garlands. The groom is challenged with games. One of these is to hit with his sword the *toran*, a wooden decoration hanging very high over the entrance. He is also challenged by his in-laws to show off his intelligence by answering riddles which are kept as family secrets. For instance:

> *"What lake is without a shore, what tree without branches?*
> *What bird is without wings, what dying without death?*
>
> *Eyes are a lake without a shore, true religion is a branchless tree.*
> *The soul is a bird without wings, sleep is dying without death."*

Through this wedding I find myself in a fascinating wealth of jewellery, bright silks, gold tassels and trimmings. It all seems to have a museumlike quality, but proves to be a very living tradition. I meet Bindu Chandela, a young woman who recently set up a small company with her sister to revive the embroidery traditions of the Rajasthani *poshaks* which have become fashionable all over India. In Rajasthan the colours one wears go with specific times of the year and social circumstances. For instance, black or the darkest of blues, strewn with sequins, gota, and glitter is still the rule at the Jaipur and Jodhpur courts to celebrate Diwali, the moonless night of the "festival of lights" in autumn. But the next morning one is supposed to wear only light pink!

Poshaks are often very old and are passed on from one generation to the next. But the artisans are still very active. A lot of research is being done on embroidery techniques with exotic names like *salma*, *zardozi* and *gotapatti*. Catalogues of textile museums from the whole world line the walls as

Bindu shows me the samples from which they have been able to trace lost techniques. Pieces of embroidery, the remains of otherwise unusable dresses, are mounted on new silks from Benares or even on antique saris, stitched with pure gold thread and wires, still owned by caring families. The fringes, which sparkle on the edges of veils that look as wide as saris, used to be made of pure silver and gold. Clothes that really cannot be used anymore are burned to recuperate the precious metal. A wedding *poshak* can easily weigh ten kilos.

I have bought numerous rolls of silver and gold ribbon in the market before I realise the importance of this *gota* as trimming on dresses: it catches light and adds shine. Used widely as plain borders, or hand-folded into triangles and rosettes, *gota* is now made of synthetic fibres. It is still woven on heavy wooden looms, which are kept in the back of the old houses of Chardar Wasa in Jaipur. Inexpensive as they are, the rolls are nevertheless bound together by pink and red silk thread. They look so rich and refined that they will forever remain unopened by me. The same shops in the bazaar sell small ready-made pieces of embroidery for dresses. Although they may have been made with a machine, a hand still controls the process and nearly every dress one sees in Rajasthan has been designed at home, and stitched and embellished with patience and love.

Following double pages:
❋ *Purdah* / stone-carved windows in Mehrangarh fort, Jodhpur.
❋ Coloured Belgian glass in a window overlooking Dungarpur / a wedding procession.
❋ Jodhpur 2001, a royal wedding: the procession...
❋ ... one of the numerous receptions...
❋ ... the *Bana* ceremony in the palace.
❋ Embroidery on *poshak* dresses.
❋ Ribbons of *gota* / small ready-made embroidery pieces.
❋ Silver *gota* ribbon made into rosettes and hand-folded decoration.
❋ *Mehendi*, henna designs on hands and feet.

Jewels

Out of a red velvet box comes a small, finely decorated gold wine cup…I sit on a bed strewn with jewellery cases. The men of the family have insisted that I see this wonder before being scientifically introduced to the many different pieces which traditionally constitute a woman's ornaments. It once belonged to the Moghul emperor Shah Jahan. Round, smooth, and heavy, not larger than an egg cup, it snuggles in the palm of my hand. I feel deeply moved. Finely enamelled flower designs in red, blue, and black are inlaid with uncut diamonds. Who would believe that this *meenakari* work, so soft to the touch, the product of so much work, is often only used by the goldsmiths as a kind of lining, on the side that touches the skin?

In Rajasthan's traditional society, her jewellery is a bride's only possession. This is why one can see such extraordinary amounts of silver and even gold worn every day in the villages and in conventional communities. In the past all the visible parts of the body had to be covered, and there are jewels for each: armbands, bangles, bracelets on wrists and upper arms, rings on fingers and toes, ankle jewellery, round forehead pieces, earrings reaching to the shoulders, and nose rings. Men always had their own jewels, matching the women's in splendour, as can still be seen at royal gatherings. Simpler equivalents adorn necks, wrists and especially ears of shepherds and others.

Silver ornaments generally reproduce the different pieces of gold jewellery, but in a simpler way. The traditional sets of arm and neck adornments, worn in a fixed order, are done in silver for those who cannot afford gold, with semiprecious stones or cut glass replacing gemstones. This explains why, when famous European jewellers arrived at the Rajasthani courts at the beginning of the twentieth century, they had a hard time promoting the use of platinum which had become so fashionable in Paris: their royal clients in India found it to look just like cheaper silver. A ruler was supposed to wear gold!

The best light for my pictures of a two-hundred-year-old necklace proves to be the inner courtyard of a famous and kind jeweller: a sheet is laid over the front of a gleaming vintage car, one of many. Both sides of this famous *hasli* have been made with the same patience and

dedication. But it is not meant to be reversible. It used to be worn between several other necklaces: a choker high around the neck, another precious piece covering the lower part of the throat together with strings of pearls and precious stones. Work with enamel for which Jaipur became famous, *meena* as it is named, involves several artisans. The goldsmith shapes the gold, which is then carved and enamelled by another specialist, then set with stones and finally strung: at least four different crafts are involved in the process. A piece of jewellery was never signed: the artisan was only doing what God meant him to do. It's another frustrating rule for the art déco jewellers from Paris and London who, nevertheless, were able to realise here their most impressive creations thanks to the wealth of stones provided by princely patrons!

Colours, like so many other things, are not chosen at random. Black and blue, favourites of the Moghuls, are seldom used by the Hindus. Considered to be mourning colours, they generally prefer red and green (auspicious and welcoming) for their jewellery. Ancient medical traditions and astrology, still practiced as the most natural of things, teach that metals and stones worn on specific places of the body keep the nervous system in good health. Which adds a deeper significance to these various elements of adornment. They are not meant only as decoration. Nine gems in particular are believed even today to influence health through their relation to the stars and planets: pearl, ruby, coral, topaz, diamond, emerald, sapphire, zircon, and cat's eye. They are often assembled in *nawrattan*, nine-stone jewellery.

One of the world's major centres for the polishing of minerals, emeralds more than anything else, can be found on the upper stories of the old houses in Jaipur's Johari Bazaar. The link with emeralds is ancient. The story goes that when the emperor Shah Jahan died, he left 750 kilos of emeralds to his son. In the workshops, ordinary-looking plastic bags are filled with impressive chunks of rough minerals from every corner of the world: emeralds, aquamarines, rubies, sapphire, or whatever stone is in demand, from Zambia, Brazil, Madagascar… Clients from some countries ask for colour, others for lustre, but it is all a matter of polishing. Watched by a foreman who grades the raw material, the cutters sit cross-legged on the floor in front of their grinding wheels. The whole place oozes concentration. Tiny lamplike ovens melt the wax used to fix the stones at the tip of slim bamboo sticks that are held against the grinding wheel. But just as often the tiny stones are held between the fingers. From sawing and

pre-shaping to faceting and polishing, everything is done by hand. Even the piercing of tiny beads, which are almost invisible when held between the fingertips, under tower-shaped drills in a spray of water.

Bangles belong to every woman's outfit, are constantly purchased and constantly lost because they are so breakable. Only widows do not wear them, having ceremoniously broken theirs at their husband's death. It has nothing to do with social background: when my friends go out shopping they can seldom resist buying a few from the *gawarni*, the bangle woman, adding to an already impressive collection at home. They match the colours of the dress in subtlety or boldness with a personal selection of glass and lacquer worn between silver or gold. Little girls wear one black bangle on each wrist "to break the perfection" and ward-off bad luck.

There is a charming poem, called *Bangle-Sellers*, written by Sarojini Naidu (1879-1949):

"Bangle-sellers are we who bear *Rainbow-tinted circles of light?*
Our shining loads to the temple fair. *Lustrous tokens of radiant lives*
Who will buy these delicate, bright *For happy daughters and happy wives."*

White bangles, armfuls of ivory *chura*, replaced these days by camel bone or plastic, are mostly worn by pastoral communities. They are even worn by babies, in tapering sets of up to seventy pieces, covering the whole length of both arms. My driver's sister was dressing her children one morning when I met her. I never dared ask if she wore her bangles at night, as someone had told me. The photograph may look as if she sat for me, but it was just one of these blessed moments, when everything seems so incredibly right.

Lacquer bangles are still made in many places. I go on the back of a scooter to the Maniharon ka Rasta, deep in old Jaipur and impossible to reach by car. Baddu, a friend of a friend, belongs to the eighth generation of the family who owns the shop. Baddu's forefathers were horse breeders in Iran before moving to Jaipur when it was founded at the beginning of the eighteenth century, attracted by the will of Maharaja Jai Singh II to stimulate crafts and to provide artisans with houses and work. "Son of Gyas Mohammad, grandson of Faiz Mohammad", is written over the entrance to the shop. The place smells of resin and a fire is burning in a small stove to soften the lacquer. Baddu explains his technique: shellac is the gum from an Indian tree. It is coloured with the same watercolours used for Holi, then shaped into

rolls on a metal plate heated by a little coal fire underneath. Finished on a wedge-shaped wooden mould, the round bracelets are sometimes decorated with little brass details and glass gems while the lacquer is still soft. Fake enamelled *meena* jewellery, done mainly in Bikaner, but sold in bazaars all over Rajasthan, is made of lacquer mixed with a stone powder, *ghyapattar*, to make it stronger.

My old friend Girdari Lal is a *lacquara*, of the lacquer's caste. He uses intricate and pretty knots in contrasting colours of silk thread, with fine metal wire to give it added lustre, to string the separate elements made by the gold or silversmiths into necklaces and bracelets. His is a special craft and a job of trust: the pieces confided to his care are often old and very valuable. Girdari Lal generally sits on a small striped durry outside his shop, chatting with his neighbours and surrounded by children. To show me his skills he tied red and gold yarns into a long tassel for my Swiss army knife and made me a whole collection of cotton bangles. Regardless of the time of the day he happily greets me with his only words of English: "Good móórning, how ááre you!" before sending someone with a few coins to get me an apple.

Following double pages:
❀ A large *meenakari* necklace.
❀ Jaipur, capital of the emerald trade.
❀ Polishing tools / raw minerals.
❀ A boy making lacquer bangles / the *Gawarni* selling bangles.
❀ Girdari Lal, the *lacquara* and his work.
❀ Satu's sister with her children / sets of white *chura* bangles.

69

Textiles

In the market around Jodhpur's clocktower I go to a shop selling a good choice of fabric. I have decided to make a *ghagra* skirt for myself. Such sari shops in the bazaar often look like enlarged cupboards. At the entrance, higher than street level, sandals and Rajasthani shoes are piled up, removed so as not to soil the white sheets which cover the floor. I sit down between the ladies of a family busy choosing a bride's dress, heaps of embroidered material in every shade of red everywhere. Roll after roll of plain cotton cloth are taken from the shelves for me, no two shades identical. It is impossible to decide! My journal lies open on notes and samples of fantastic colour combinations I have observed on people. Having to choose for myself now, I realise the boldness and creativity of the women in putting together their dresses, and feel very limited. It is not a simple game, to play with colours when the choice is endless!

I always note what I see, in the hope to learn: "Swinging cobalt blue skirts, high on the ankles with vermillion hems; a lavender cotton blouse, block-printed in small dark red designs. A Prussian blue skirt, mauve and apple green blouse embroidered with gold through a transparent veil in fluorescent pink and more gold. Black skirt, black blouse, dark red odna, small embroidery and lines of narrow, multicoloured silk ribbons trimming the edges. Dull reddish pink odna veil tie-dyed with white and black dots. Men in white *dhoti*, dark blue *kurta*, red *safa*."

A whole film filled with photographs of turbans: piles of freshly dyed turbans, a good thirty pieces, have been ordered weeks in advance for a wedding and delivered to the home where I am staying. The technique involved in their making is clouded in alchemical mystery. The dyer has come with his "shaded" samples, a beautiful bundle made with the edges of finely woven cotton turbans, one colour bleeding into the next. Such quality is becoming rare. Tayeb Khan, the handsome master dyer, proudly explains his work to me, then starts talking about his dreams of becoming an actor in Bollywood.

Safas, as turbans are called, are like the Western man's tie, the finishing touch of elegance. They are charged with significance. Throughout history, a pledge would only be ratified with the exchange of turbans. Many songs and stories commemorate the saffron *safas* and the deeds of courage of the

final battle. They were worn only when all was lost, and inside the forts the women committed *jauhar*, ending their lives in the fire before the enemy could capture them. Turbans serve all kinds of purposes. Shepherds use the meters and meters of cloth to protect themselves from the sun, to fetch water in deep wells, to attach an animal or, so I was told, to tie the hands of a thief! I also heard that the proud and stylish heavily moustached Rajasthani man may store comb, pipe, and small mirror under his turban. And at the crack of dawn in a tented camp in the desert I saw on the guard's *charpoi* the flattened shape of a *safa* which had clearly been used as a pillow. I have a special memory of two men standing ten meters from each other on the steps of a lake after a bath, holding the ends of a yellow turban while stretching the material as the wind blew it dry. Another recurrent image is that of a seemingly endless length of red being rolled and turned as it is being casually retied by its owner on his own head during a conversation with other men.

Dress, like the dialects, varies every thirty kilometers. An insider cannot fail to pinpoint caste, occupation, and regional identity for men and women alike. And there are fashions too: on each new visit I find that the scene has changed. The headgear carries unmistakable signs of social status and circumstances. Bright and colourful stands for happiness. Spring is heralded with the red and white *phalganiya* colours. Dull *pukka* greens, khakis and whites are for mourning while soft pink will be given after a funeral, and the *bandhej* tie-dye masters improvise on the traditional five-coloured turban with red, white, saffron, green, and blue.

Narrow *paghs*, like the chevron-patterned turbans shown here, are the traditional headgear of Mewar, the southern province of Rajasthan. My friend the dyer tells me that much of the traditional knowledge for achieving the narrow crossing lines tie-dyed in my old collection of *laheria* has disappeared. Today the patterns are much simpler and irregular. Nobody is able to make the intricate folds needed before plunging the cloth in the colour. A nice detail about the dyes: they were never fast, they would "bleed" and this was on purpose. There is many an old song about the pleasures of watching colours run over a beloved's body in the rain. Waves are traditionally associated with the monsoon, the rainy season, the festival of Teej in August.

The dotted patterns of tie-dye are always tied by women with the thread wound around little spots of pinched material or over a pointed fingernail underneath. They follow lines which are block-printed in pink ink on the folded and layered cloth. The frilly mass is then brought to the dyers,

always men. Sometimes repeated sequences of tying, dyeing, and untying are carried out with different colours for a rainbow effect on one pattern, like the square *dabbi* or box patterns of Jodhpur and Bikaner. After untying one can count the times it has been dyed, one for each separate colour. After drying, the meters of completed material for saris, skirts, or veils are separated with great dexterity in the shop, leaving the floor of many a sari shop strewn with millions of little coils of coloured thread, which I would avidly put in my pockets!

In the areas around Barmer and Jaisalmer one can meet women clad from head to toe in dark red to almost black shades of maroon. It is intriguingly different from the luminous dresses one is used to seeing, the theory being that the less colour in the landscape, the brighter the clothes. At first I thought that they were widows wearing these dull, worn colours. Called *reta*, the colour is based on a mixture of iron scrap for the blacks and alizarin for the reds, the edges sometimes revealing remains of green and blue. I had to find some samples, which I bought deep in the Barmer bazaar; they were so saturated with dye that they left my hands very brown!

One cannot fail to notice the typical bright yellow silhouettes of women wearing the *pila* odni veil. In spite of lots of variations, it is definitely yellow and very bright. In the tradition of a male-dominated Rajasthani culture, it is worn only by women who have become the mother of a boy. And strangely enough they receive it from their own parents on *Suraj puja*, the ninth or tenth day after the birth of the child.

Deep in old Jaipur's Panigaran area coloured water runs in the street. Cotton yarn has been tied and boiled several times in brass pans in the open air. Looking like long necklaces or like thick rope, strings of sacred *moli* thread, still tied together, are drying in the sun from the roofs of the houses. Once dry they can be untied into stripey yellow and deep red cotton fibres. The multicoloured variety called *latcha*, found on the endpapers of this book, is only manufactured in Ajmer. Each colour requires new tying and a separate bath of colour.

It is close to rivers that one finds the *chipa mohallas*, the block printers' areas: in Sanganer, Bagru and other villages near Jaipur, in Balotra on the way to Barmer, in Akola. Industrial screen printing is replacing many traditional workshops: huge quantities of finished material are produced in far less time. But it lacks the charming imperfection of hand prints, the blocks for which are carved by hand out of hard wood and sometimes signed by the maker. It requires considerable precision: several

blocks are needed to print the different colours of one motif, and a good carver needs to have a thorough knowledge of printing together with a good eye and a steady hand. A block will last for about 2500 meters of printing, depending on the kind of colour used. Blocks are inherited by generation after generation, cherished and repaired, some designs impossible to reproduce any more. Brass blocks, with very fine designs, are rare and expensive and used for *khagzi* work, gold print.

At the workshop, lengths of six meters are printed on long tables. One craftsman follows the other, adjusting the corners of his block on the previous imprint with great precision and amazing speed. I have watched a master craftsman work with white on white muslin, the details hardly visible as he went forward, until the cloth was held in the light to reveal the finest mesh imaginable.

The red and blue *ajrak* is worn by Muslim camel breeders and shepherds between Rajasthan and Pakistan. Used as shawls and often printed on the silkiest of cotton, *ajrak* is printed with blocks. The intricate web of motifs does not allow mistakes. Natural dyes of indigo and dark red *malir* give it a soft look which wears well, and sometimes a costly treatment of the material before printing, when it is boiled for days, allows the design to look perfect on both sides of the shawl. I have been told that it is through the direction of the printed patterns, vertical lines for Hindus, horizontal for the Muslim, that one can recognise the different communities. It is one of my favorite designs.

Following double pages:
❀ Starched silk georgette turban / hanging cotton skirt or *ghagra*.
❀ Tayeb Khan the dyer's skillful art: wedding turbans for the princes and his samples.
❀ Narrow turbans, or *paghs*, in wavy *laheria* patterns.
❀ *Bandhej* tie-dye textiles.
❀ Large box-shaped *dabbi* tie-dye motives / Gita Bai at Rohet.
❀ Maroon tie-dye, called *reta*, for dresses in the Barmer district.
❀ *Pila*, the golden yellow veil for the mother of a boy.
❀ Sacred thread dyers in Jaipur's Panigaran area.
❀ A man and a woman working at the dyers in Akola and Bagru.
❀ Washed textiles.
❀ Two prints of blocks for a tiger-skin design.
❀ The block carvers.
❀ Four blocks shape one flower design / view on the riverbed at Akola.
❀ Blue and red *ajrak* print on a Sindhi man.

Pigments

A bright September day in the old streets of Kanda Falsa, in the heart of Jodhpur. I have taken pictures from early morning at several derelict step-wells hidden between the houses. As nobody looks after them anymore, my interest in them has attracted quite some curiosity. It is suggested that I would have a better view from the top of a nearby house, would I like a cup of sweet coffee?...an occasion for my host to stop his daily routine for a moment and to show the consideration for a stranger which is so much part of Hindu culture. High and narrrow stone steps, hollowed by centuries of use, lead me upstairs, between turquoise green walls, from the ultramarine facade. On the way up I get a private view of a clean and orderly house, where several related families live together. At this time everybody is out. Once on the roof, a different city comes into view: conversations go on from one house to the next while spices and pulses are laid out to dry between *charpoi* beds turned sideways, used by the whole family for cooler nights under the stars. The lady of the house, in a purple sari glittering with tiny silver dots, hangs out lengths of bright orange cloth for the colour to set in the sun… Her husband, she tells me, is a *rangrej*: *rang* means colour and *rej* a dyer, and I should be able to find him working close by.

In Chadwa Street I first pass the tiny shop of the *rangwallah*, who sells their colours to all the dyers of the neighbourhood. It is nothing more than a small cubicle in which the owner has folded himself up, with lines of boxes of chemical dyes, often manufactured in Germany, and a beautiful pair of old scales. Here one can also buy bags of *neel*, the velvety ultramarine-blue powder which brightens white laundry and is used for breaking the blinding intensity of whitewash on the walls of houses.

Research on the use of natural dyes, as opposed to the synthetic ones, is done only on a small scale by a few devoted artisans. All kinds of yellows come from the skins of onions or pomegranate, turmeric root or hibiscus flowers; when mixed with indigo they give beautiful greens. Different reds come from alizarin with alum, copper sulphate, tin chlorite, even wood of the gum tree; blacks are done with iron scrap and alizarin. Reactions from using some acids with colour, or from mordants on the cloth, lead to the most subtle in-between shades. And the sun's work is

essential: colours look much richer when done in warm, dry weather than when done during the humid months of the monsoon. But it is a long and labor-intensive process. In the past the dyers kept their recipes secret within the family: even their own daughters, since they were going to marry into other families, were kept out of the process.

Further down the street, the dyers are at work: the atmosphere is filled with loud Hindi movie music, splashing sounds, laughter at someone's joke, and then curiosity at seeing me, which stops movements for the briefest of moments. I am shown around and questions about my work are asked and translated for me. In a courtyard, a pile of used bicycle tires is being cut into long narrow strips. Almost everything is recycled in India, and these tires are re-used to wrap and tightly tie parts of the textiles, stopping one colour after the other from penetrating the cloth during the different stages of the long dyeing process. The dyer and his assistants work around several open fires in the growing heat of the day, adding powders to the brass cooking vessels. It looks so simple. But the often incredibly intricate results require many days of work for several people. Eventually the finished bales of silk and cotton are taken to their destinations in hand-pulled carts: no other form of transportation fits through the winding network of narrow streets.

Next, I visit a painter's studio above a ceramics workshop in the outskirts of Jaipur. More pigments, but the peace and refinement here are in total contrast with the heavy physical work of the dyeing processes down on the pavement of the Old City. Kripal Singh Shekawat was not meant to become an artist. Born into a family of aristocratic landowners, his love of art manifested itself at a young age and he had the luck to be allowed to study painting with a master in town. Still a young man, he was asked in the 1960s to research the almost forgotten techniques of blue pottery which came to India from Persia with the Moghuls at the end of the sixteenth century and for which Jaipur became famous. By that time he was already a dedicated painter of miniatures, another art which came from the Iranian court. There has been a long and receptive tradition of painting in India, first on cave walls, later on palm leaves and still later on paper from Tibet and Nepal. "Though Islam forbade it, artists couldn't resist depicting the beauty of nature, says my host, so these paintings had to be hidden and were kept in the form of small books."

Nobody knows more about traditional colours than Guruji, as Kripal Singh is affectionately named by his students. The bookcases lining the walls are filled with volumes about artists from

around the world; he has travelled and taught extensively abroad and there are always foreign students working with him in Jaipur. While he works, cross-legged on the floor in spite of his age, surrounded by flasks and shells and his own blue ceramic containers, he tells me where the traditional pigments come from and teaches me how to look at miniature paintings. It is not easy to distinguish between old and new, for techniques and themes have not changed much over time. He teaches me to recognise the different schools of Rajasthani painting: Jaipur, Bundi, Mewar, Jodhpur...the use of different colours, local dress, desert or lush backgrounds, and of course the profile of the famous *Banithani* lady, with her elongated eyes, long lashes and a sharp long nose, invented by the king and poet Nagri Das in the eighteenth century, typical for Kishangarh.

Miniature painters make their tools themselves. The finest brushes are made of squirrel hair - sometimes only one or two. Ground minerals are mixed with gum into paint. Antique paper is cherished as the best working surface and an agathe stone is used to make the painting shine after completion. But in a trade where making a good copy is one's daily bread, what makes a painting stand out is facial expression, calligraphic skills and, rarest of all, personal style and originality in depicting traditional historic and religious themes.

Many pigments used in India are produced locally. While showing them to me, Guruji applies a dot of each in my notebook. There is terre verte (a celadon green from a stone found in central India), yellow ochre, warm Indian red, carbon black, chalk white, lapis lazuli blue, dark maroon from Bikaner, and *gehru*, or burnt sienna, from Iswal near Udaipur, also used on the pink facades of Jaipur and on red earthenware. Of the many stories Kripal Singh tells me, my favourite is about the famous "Indian yellow". Made from cow's urine, its fabrication is now forbidden. Legend has it that jaundiced cows were made to stand in the sun and eat mango leaves, which turned their urine a deep yellow. When diluted with water, the smallest quantity of pigment gives a bright, golden yellow paint which is very difficult to reproduce with chemicals. While happily saying that what is left in this tiny, two-hundred-year-old glass container is more than enough for the rest of his life, Kripal Singh removes the cork and a strong smell instantly transports me into an imaginary farm yard.

Following my visit to Kripal Singh, his lessons still fresh in my mind, I pass a façade in Umaid Nagarh on the road to Osiyan, its paint still wet: its colours and themes are a witness to the same

living tradition, but on a totally different scale. The light has such a quality in India that these kind of extreme colours never seem too harsh, while even the more subdued shades would still hurt many an eye in northern Europe.

It takes some asking before I find the house of a famous dyer in the outskirts of Jaipur, after a day on the back of a scooter through different crammed artisans' quarters. When I actually reach him at the dyers' *mohalla*, it is five thirty in the afternoon and dusk is setting in once again. Working tools have been cleaned, bodies washed. "The Bold and the Beautiful" plays on a distant TV set, good smells of cooking, a baby clinging to his father's leg, peace after a hard day of work. The carved stones at the entrance of his house, splashed with colour, the turquoise water still flowing to the gutter nearby and the indelible dark colours on the skin of his hands will always betray the man's occupation.

Following double pages:
❋ Dyed cloth and dyers in the old streets of Jodhpur.
❋ A pigment seller and pigments.
❋ Jaipur blue pottery / Kripal Singh: miniature painting.
❋ The outside walls of a house on the way to Osiyan.
❋ Coloured stepstones at the dyers'.

C.E.20571

ATUL LIMITED
Colors Division
P. O. Atul 396 020, Gujarat, India.

261111 /B/ 021903

G 8.70 Kg.
T 2.70 Kg.
N 6.00 Kg.

FOR INDUSTRIAL USE ONLY

420512
─────
50
DL1

Kites and papers

It is evening after a warm day on the flat banks of Man Sagar, the lake surrounding the summer palace near Jaipur. This is the best place to watch the kite clubs come to practice their skills. They sit far apart. One needs good eyes to distinguish the tiny squares high above one's head, but my guide who loves flying kites himself tells me what I should see, the details of a fight going on at the end of five-hundred-metre-long strings... A new challenger has already won over several other people whose kites have been mercilessly blown away by the wind. Victory was achieved by cutting the opponent's kite with a string coated in finely grounded glass, and the victor stands on a roof nearby. Loud cheering greets each new success. Everybody knows who this year's champion is and where he lives, but this is someone new! The teenage daughters of the house where I am staying practice flying skills from their terrace after school, but only after making sure the challenge is worth their while. Makar Shankranti, the one-day kite festival in January, is approaching. This is serious business. Stakes are high.

Poets have often used kiting gestures as metaphors and there are kites on many centuries-old miniature paintings. On the roof of the palace of Jaipur there is a section called *Patankara*, with the *Kothari ka kamra*, the "kiting room", and adjacent to it the *Tukal ki kothari*, the kite store. Maharaja Sawai Ram Singh II, who was very fond of flying kites, was known to take the competitions very seriously. His kites were flown from Chandni, a big roof terrace. On each one was written: "If anybody captures this kite, please bring it back to me." One day in 1864, the royal kite was defeated and the winners, two men called Khuramani and Kaluram, from Bharatpur near Agra, were told to come to the palace. Shaking with fright, they came in their loincloths asking for forgiveness! But His Highness was intrigued by their apparently easy victory and asked them their caste and how they had achieved it. They replied that they were potters and had used a trick: they had coated their strings with the crushed blue-green glass glaze they used for their pots, turning them into flying knives! It is said that Sawai Singh asked to see their work, liked it, and thus blue pottery came to Jaipur along with the two kite champions.

Sitting outside his workshop amidst fine strips of thin coloured paper and pots of self-made glue, Munna Bai, the *patang wallah* or kite maker, talks about the work he has been doing for the past forty years. Inside the tiny shop, his assistants are cutting narrow strips of red paper for the tails. I get some to put between the pages of my journal. Different models of kites are neatly stacked on shelves. They are much smaller than I had expected. There are "female kites", called *Chandara*, meaning "moon", with a round shape in the middle and little floating paper tails at the end. "Male kites" are called *Akaldara*, which means "eyes", with two almond shaped eyes and a sort of triangle as a base which looks like a moustache. The kite's frame is made up of a cross of split bamboo sticks. A thread is run along the sticks' ends, and paper is lightly folded and glued over the rectangle thus formed. Finally, decorative elements are added. The paper is burnished with a polished agate stone to make it smooth, flat and strong. In spite of all this work, a kite costs not more than ten to twenty-five paisa, which is almost nothing. Before leaving I am told with insistence how essential it is to bend a kite both in width and in length over one's head before flying it: only then will it catch the wind as it should.

Over the bridge near Sanganer, between tall racks of freshly dyed cloth, one can see rectangular brownish sheets drying on the ground in the sun: it is cardboard. The water from the river is said to have properties which are important for the manufacturing of textiles, so Sanganer, like other places on rivers in Rajasthan, became an important centre for printed cotton. What is left over from the textile-making is used in the production of all kinds of artistic paper. Camel carts stacked high with bundles of cotton give the little town a medieval flavour, belying the volume of international exports. There are only a few workshops left in the traditional houses of Sanganer, but even in the modern factories the process is still done largely by hand. Women sit on the floor cutting roses and marigolds and coloured thread into little bits. Men slosh in water between the tubs, lift and turn the frames on which the paper pulp is picked up from large vats, press the water out, lift the sheets between thin layers of cotton cloth, then hang them to dry before starting to flatten the dry paper between metal cylinders in the big calandring machine. There is a lot of echoing noise. And there is much to see in the lines of hanging paper, the curves of the unfinished sheets, and the stacks of multicoloured rough edges of paper being prepared to send out the world over.

Bookbinders in the bazaars of most cities in Rajasthan still make the traditional red account books, called *bahi*. Nanda and Shankar Lal—is it a coincidence that Lal means red?—have started using synthetic, washable cloth for the covers, but I prefer the darker red cotton which matches well with the decorative yellow and sometimes bright pink edges. A heavy sewing machine stands at the back of the shop to stitch through the finished covers, cardboard included, with flowing designs in white or yellow thread. Bahi are sold in all sizes and I can never resist buying a few more for a growing collection at home. They are used for any kind of business accounts. This explains the religious images bound inside as endpapers: the ledgers are offered at Diwali in November for blessing by Lakshmi, goddess of wealth, and the reproduction of Ganesha is auspicious for the start of any project. A pair of scales serves to weigh the thickest books, made on order for the temples that register family genealogies. Looking exactly like the small ledgers, with the same white length of string to hold the pages neatly tied, they can weigh up to ten kilograms. Ordinary bookkeeping is done in a much simpler way, the bills held together by a thread hanging from the ceiling!

Not far from my favourite shop in Jaipur, I hear a constant tapping, fast and very loud, a sort of modern percussion orchestra at rehearsal… There are musical instrument shops in the area, and I think the rhythms come from the drum makers. But I am directed towards the towers of the mosque. A surprise is waiting for me: in a wide open square under the tall towered building, there is a multitude of open workshops, shaded by trees, where young men sit together on the ground as if they are playing cards! Holding heavy hammers, they pound on leather booklets which their left hand keeps turning regularly clockwise. In this way they flatten ribbon pieces of very pure silver or gold between small sheets of what looks like saffron stained parchment. The floor is covered with talcum powder scooped from bowls by white hands and lavishly used to prevent the metal from sticking to the pages of the leather books. Right and left hand seem to be working together with great precision, no fingers being hit while a pile of the thinnest foil is shaped inside. The irregular rectangles obtained after beating will be cut to shape by the wives at home, and what falls will be melted by gold and silversmiths for the process to start all over again… While I stand watching in amazement, the work is abruptly interrupted for prayers—*namaz*—by the muezzin. The interlude is brief

before the percussion sounds start again, continuing for hours with full intensity.

Silver foil is used on the rectangles and balls of sweet almond-flavoured *mithai*, as well as by artists and ayurvedic pharmacies. It is widely applied on religious statues. Sometimes vermillion paint and silver add shape to totally uncarved stones which stand for one of the gods or are believed to store a potential miracle. As well as sacred thread, sweets, and incense, it is one of the things offered for worshipping. The much thinner gold is also used in medicine, and for gilding, for instance, the spires of temples. I can't resist buying a small packet at a sort of shop under the mosque; each sheet is neatly wrapped in white silk paper, a thin cotton thread ties them together. I will keep it unopened, knowing very well that I probably paid far too much for the flimsy metal.

Following double pages:
❀ Old houses in the Shekawati area of northern Rajasthan.
❀ The kite maker.
❀ Handmade paper: colours of the rough edges.
❀ Paper factories at Sanganer.
❀ Paper samples.
❀ Red account books, or *bahi* / traditional book keeping.
❀ The drum maker.
❀ Gold and silver leaf.
❀ Silver leaf on deities in the temples.

Holi

Early spring in Rajasthan carries a special kind of excitement and increased activity. The houses are cleaned, repaired, painted. Winter harvest is finished and a new season is introduced carrying hopes of prosperity and fertility. The markets are full of life, with lots of shoppers buying new clothes for the whole family and things for their homes. And at this time the familiar walls of houses emerge a different colour from last year, tailors seem to be working non-stop, and at the dyers it is all reds, purples, and whites or light pinks. In the streets, the saris and Rajasthani dresses, normally so diverse, turn more and more to mainly white and reds: *Phalganiya*, as they are called.

I have been travelling for weeks, but the festival of Holi is coming. There is too much to see to remain lazy. My hosts are definite: now that I am seriously doing a book, how can I cover my subject without staying for this month of *Phalgun*? After that is *Gangaur*, at least as important, celebrated nowhere else than in Rajasthan. The stories are wild… And so, urged by my friends, I stay on.

Bright powders in many colours are being sold from paper bags on every corner and the buyers, when they see me, take on an air of conspiracy and fun. People's clothes, normally so clean, are often covered with bright pink blotches which nobody seems to mind at all. Dry colours are lavishly thrown on passers-by and the widely available water pistols, or "super-soakers", make any errand in town more and more hazardous. At the entrance of the fort at Rohet, old Tana Ram's grey head has turned a deep lavender. His sense of humour makes him a loved target. Splashed with pink, his white *kurta* pajamas became a work of art weeks ago.

Tomorrow will be the actual day of Holi. The large, flat chung drum used only this time of the year, has been played each night for weeks, the obsessive beat, one long two shorts one long, ___··___ , ___··___ , ___··___ , ___··___ , going on for hours. Loud singing makes the dogs bark furiously. During the day groups of girls chant "Holi songs" and gather together, secret fun on their faces (nobody is prepared to translate the texts for me; I am told they can be quite obscene!). My young friend Avijit, eight years old, shows me his comic book with the

story of the child Pralad, who survived the fire where he was held by the demon Holika. The religious part of the celebrations, the "burning of Holika", always held on *Poornima*, the full moon, has been set by the priest for three o'clock in the morning.

Surrounded by men in colourful turbans with serious expressions on their faces, I sit in the front of a jeep next to a huge rifle. A small group of other Rajput villagers walk around us towards a shrine near the lake to the incessant beat of the drum and the *thali*, a kind of flat metal dish hit briskly with a short wooden stick. I feel thrilled and honoured, even my hosts have never attended this religious ritual, and great effort is taken to explain the procedures to me in broken English. Lit by the jeep's headlights, a thick branch is wedged upright in the sand and hung with cowdung patties and some garlands; kindling is added. Prayers, a gunshot, the fire is lit and tall flames rise in the dark night. A wide circle of faces light up in the golden light. Women stand aside as men run around the fire loudly rejoicing, fathers carrying their new-born *doond* babies dressed in golden gota to protect them against the evil spirits. I am asked to take pictures in the dark. Tomorrow the whole village will be treated to sweets by the parents going door to door. The whole thing is over in ten minutes. Strings of elated people start walking back to the village. The ashes, left to cool, will be picked up tomorrow for the first ritual leading to Gangaur.

There are many other fires around us: each community has its own. Eager for the rain-carrying southwesterly winds, people watch which way the smoke is going. If it goes straight up it will be bad for rains but good for peace, they say, and no diseases will come. In the same way, if at Diwali in November the lamps burn nicely it means there is no wind, which is a good omen for the autumn harvest. All the Hindu festivals follow the rhythm of the seasons.

Next morning in a village outside Jodhpur, the different communities (Rajput, Brahmin, Kumar potters, Sutar carpenters, Mochi cobblers, Kalbelia snake charmers, etc) arrive in order of importance—dancing and singing, sometimes disguised as women—to pay their respects to their local lord. The pastoral Raika sing songs of valour about the wildboar hunting for which the area is famous, and about this family, who was among the last brave men to fight the British. The festive mood keeps rising around the opium ceremony, the sharing of sweets, of *bidi* cigarettes and a lot of *bhang*, a narcotic drink. It has been like this for centuries.

Today one is going to "play Holi" and the newspapers are full of "Happy Holi" ads. More than anything, Holi is about being merry, making fun, and letting go of grudges by singing freely about each other and by "playing the colours". As the much loved and quite free Krishna "played the colours" with the *gopi* milkmaids, anything can be said and sung. Avijit walks around with a mischievous air, asking "who shall I rangoor?", meaning "who will I thoroughly colour?" In past times fountains used to be filled with pink water made from flowers and in many palaces there is a "Holi courtyard", or a *Rang Mahal*, meaning palace of the colours. At Rohet, where I am staying, huge metal cooking pans are filled with water mixed with handfulls of colourants, plastic bags full of wet colour are flung from the houses, and thrown powders make yellow, green, and red clouds. Only people's eyes remain clear in the dark purple faces. By the end of the afternoon, with traces of pink still very visible on their skin—and worn with pride during the following days ("one should be able to see you played Holi")—the ladies come in to dance the *loor* in the *zenana* courtyard, out of sight of men. The melodies are simple, only a few notes sung in high-pitched voices. It is a contest between two groups, and there is a lot of laughter about the improvised songs.

Gangaur follows Holi with two more weeks of ceremonies and holidays. It is a women's festival. As she sits on the porch of her house with warm winds sweeping dry *neem* leaves in the garden, a charming old lady tells me how her grandmother taught her the stories and the rituals from long before she was married (at the age of fourteen). Gauri, another name for Gangaur, is the goddess of abundance, like the Egyptian Isis or the Greek Ceres. She also provides women with good husbands. During the festival period small plaster effigies painted with colourful stripy skirts are sold in the market. There are many stories about Gangaur and her husband, Isar, who can be seen as a kind of everyday Shiva and Parvati. In the shrines to the mother goddess, offers are made with feminine attributes, *khajal*, red *kumkum* powder, *mehendi*, bangles, and amusing miniature household equipment made of clay. Behruji is worshipped now more than ever. This naughty fertility god is often represented merely by a stone and some coloured paper outside of the temples, and wheat is sown in pots at home to represent new life.

The spring festivals are a time for socialising, and are also good training for huge wedding parties! There is a saying: "*Gangauria me gora ni dorsi to kad dorsi*"; "if horses do not run wild at

Gangaur, when will they?" More new dresses have been stitched: colours and glitter transform the courtyard of the zenana into an elegant room, centred around the standing figures of Gangaur and Isar in beautiful clothes, wearing their own sets of precious jewels, Isar's turban covered with small gota *turries*, little pins of gold tinsel. To underline the religious importance of these two weeks, the ladies dance every night before the effigies. Manganiyar musicians accompany the gracious swirl of inward-looking girls and their mothers with songs of the desert, intricate rhythms on simple instruments. As almost everybody is fasting, evening food consists of the *dhal batti* of desert gatherings: balls of fragrant bread baked in hot ashes, served with a curry of vegetables. The new moon is hanging as the thinnest of sickles in the sky. Temperatures will now start rising. Prayers and offerings are made to the fierce goddess of smallpox, Sheetla Mata: a special fast is held for a whole day, when no fire is allowed in the house and only cold food is eaten. During these weeks shops are closed at the most unexpected moments, and life in the bazaar is at a standstill after many weeks of intense activity.

Then, after sixteen days of prayers and parties, the statues of Isar and Gangaur are carried in procession to the water and bathed before returning to their home for another year of sleep. Summer is on its way, dry and scorching. Rajasthan will pray for rains.

Following double pages:
❋ The month of Phalgun before Holi.
❋ *Phalganiya*, the red and white saris worn during Phalgun.
❋ The burning of the demon Holika on the night before Holi.
❋ Playing Holi or "playing the colours".
❋ Songs and dances for the spring festival at Rohet.
❋ Preparations for the festivities of Gangaur.
❋ Gangaur dances.

On the road to the countryside

After having spent days on the back of a scooter riding through narrow overcrowded streets in the oldest quarters of the city, a longing for quiet begins to take over. However no journey should be started, so I have been told, without asking the gods for a blessing. The car stops at the outskirts of Jodhpur. The driver, knowing my curiosity, invites me to follow him to an old temple, one of many which, according to tradition in Rajasthan, can date back to the mythological Pandavas of the Mahabaratha. Some "temple trees" growing inside are said to be a thousand years old. Carrying the *prashad*, white sugar sweets blessed and given by the priest in exchange of our offerings, we are now ready for a long journey westwards, towards Barmer where a recent epidemic of malaria has made foreigners more reluctant to visit than ever.

Further on, towards Pakistan, are the temples at Kiradu, the only remnants of a prosperous town of the eleventh to thirteenth centuries. We leave Barmer long before dawn and get stuck twice in the sands of the Thar Desert. There are herds of chinkara gazelles jumping around. Half hidden by flowering cactus, the refined honey-coloured buildings appear before us like a mirage at the end of the last tarred roads. The style reminds me of the Solanki architecture of western Gujarat, and I hear later that the Parmar and Mahadeo kings, who built the place on a forgotten trade route, indeed lived during the same period. Muslim traders using this route and recurring earthquakes later destroyed the temples. They clearly have been rebuilt; the finely carved stones are sometimes strangely assembled. Nevertheless, in the early sunshine, the cluster of towers and arches, doors and pillars have a grandeur of an almost unreal quality.

This region is one of the wide "semi–arid" and deforested areas of Asia, a harsh desert, "the abode of death", as it also has been called. Roads vanish into dunes which are moved within hours by sandstorms. The dunes themselves have the unblemished ribbed patterns of a seaside at low tide; I keep wondering where the water has gone. There seems to be only sun, wind, and low bushes. But people inhabit the Indian desert and there has been civilisation here for a very long time, with a refined sense of survival. Hardly a stretch passes where one will not find a few huts, men with some cattle, antelopes, and the bright silhouettes of women carrying two or more pots on their heads,

walking twice a day towards a well which can be miles away. Life follows its own rhythm, of which man is not the master.

Winters in Rajasthan, though short, can be incredibly cold. Frost is not uncommon at night in the desert, and when I take these pictures near Bundi I wear gloves. In December and January fires are started as soon as the sun is gone, but houses and people are not very well equipped for such low temperatures. Warming sweet tea flavoured with ginger and spices is always offered on a visit. The *dhabars*, restaurants on the road, are favoured stops, and places like the tea stall under a huge banyan tree outside the walls of Samode are typical for this desert region. At the junctions of highways in places like Nagaur, *dhabars* have become important institutions. A huge agricultural fair is held here every winter, and trucks carrying bulbous loads of chili peppers, corn, and wheat from the prosperous parts of Rajasthan always stop in Nagaur for a rest. Traffic is intense. This is a man's world, stained with oil and grease and coarse stories. Hand-painted inscriptions on their vehicles are supposed to protect the drivers against the perils of the trade: "Wait for side. Use dipper at night. Horn please." Or the more spiritual words of wisdom alongside images of the gods: "Think over and over again what will go with you" (meaning what you will take with you when you die).

Rows of *charpoi* are aligned in front of the open-air restaurants. The surface is "woven" on simple metal frames with strips of truck-tires piled high on the roadside at Nagaur. At all times of day men will be found asleep, resting from challenging drives. Meals are cooked in rows of pans on fires burning within handshaped earthen stoves. Chapati, vegetables, and a dhal with pickles are eaten while exchanging the latest news from far away before the drivers set off again on risky journeys to Bombay or the north.

Following double pages:
❁ Doors and pillars in Mandir Sangji, Sanganer, and Maha Mandir, Jodhpur.
❁ Temples at Ambaji and Kiradu.
❁ Kiradu, lost far off in the desert.
❁ Sunset on the Arawalli hills near Barmer.
❁ Winter morning near Bundi.
❁ Tea stall under a banyan tree under the walls of Samode.
❁ Nagaur: *dhabar* roadside restaurants.
❁ Made from tires: the *charpoi* beds of the truck drivers at Nagaur restaurants.

The way to the water

Early morning sunlight, the air crisp and clear: we encounter a group of women on their way to the well, a tower of round clay and brass pots on their heads. On our way back at the end of the day, more tall silhouettes form long soft shadows in the dusty light. The weight of the full *matkas*, water pots, is considerable and the walk is often several miles long, but the gait is unfailingly elegant, backs very straight with wide skirts flowing around the ankles. Water is fetched outside of the smaller villages, either from a lake, a small well, a "step-well" with a "Persian wheel" turned by an ox, or a hand-operated pulley with buckets. Sometimes donkeys are used to carry the water in large bags, but generally it is carried by the women. Efforts are now being made to dig wells within the settlements, but the ritual of fetching water goes on as ever before: this remains the women's domain, an escape from the house, a chance to meet other women, to talk without the presence of men. They do not intend to give away this small portion of freedom! And while it seems rather risky to walk alone over such distances, there has always been a rigorous social control around water places: anybody bothering a person on the way to the well is reported and subject to the village council.

The way to the water (*pani* in Hindi) has inspired many romantic stories and folk songs. There is a famous song sung all over Rajasthan, called "Panihari", about a girl who was married young, after which her husband had to go away. While she was whining about his absence, the monsoon had changed the desert into an enchanting place. As she was once more sitting at the well, a handsome man came by on a camel. Recognising his young wife, now grown and beautiful, and seeing that she did not, he playfully said to her: "Why are you sitting there unhappily waiting for an absent husband? Come and elope with me on my camel." Shocked, she refused to reply. As she returned home ready to complain to her mother-in-law, the young husband rode into his home...

Until independence, the maintenance of the reservoirs, or *tankas*, was the responsibility of the village as a whole. One heavy downpour would fill it for months. The catchment area all around, where the rain water is filtered by the sand, was considered a sacred place and kept meticulously clean: no shoes were allowed, no washing either, and without accumulated mud the ground remained porous. Water management obviously is a major worry in the desert.

The mud, which is removed from lake bottoms during dryer periods, has always been used by the local potters and brick makers. This is why one can find brick "factories" near water. To me they are a continuous source of joy for the eye: not only because of the colours of the people at work, the women in their saris in all this mud, but also for the clay, shaped in simple rectangular moulds, which is lined up to dry in the sun. The endless lines form all sorts of rhythms, and the constructions made to fire the bricks are often impressive. They look like large houses in the fields near the road. Built out of layers of firewood and charcoal, between the either fine or coarse blocks of clay, they have intricate systems of channels for funneling air to keep a smouldering fire going for days or even weeks. Pink layers appear where the bricks are fired; the darker areas are still raw. Red *chudi*, or bangles, hang at the entrance of the air channels and painted tridents ask for Shakti - the Goddess - to bless the business.

Traditional wells and tanks are now often neglected. Canals, which are supposed to carry water from further away, are often polluted and there are many places where wells dug deep into the subsoil are producing rather saline water (to the extent that cultures of saltwater fish are now being tried in Rajasthan!). During long droughts, state-organised works try to restore a tradition that proved to be not so bad after all. One of these projects gave me a wonderful opportunity to take pictures. Watched by a foreman who was sitting idle under a tree, women had been working at cleaning one of the *talabs* near Barmer. The groups of women were spreading out to settle down for lunch, obviously separated by caste. Covered with silver ornaments and so many pieces of textile in spite of the heavy work, they all looked, as my daughter once reflected, "as if they were working on the road in their evening gowns".

Following double pages:
❁ A watering hole in the dry countryside, Barmer district.
❁ Mud for pots and bricks.
❁ A brick kiln looks like a house on fire.
❁ Women at lunch, Chotan, Barmer district.
❁ At the lake in Dudli, Pali district / wall painting in Bikaner Fort.
❁ The potter fetches water, his children play at home.
❁ Round *idanis* cushion the waterpots when carried on the head / socialising near the water place.
❁ "Persian wheel" to lift water at the step-well of Narlai.
❁ Boy with donkey carrying water bags to the village, Barmer district.

A village

Long ago, before a village was founded, a tree would be planted in the proposed site. It was only if it put down roots and started growing that the place would be considered auspicious. Then settling could start. Lost somewhere in the dry countryside of the Pali district, Dungarpur village is nothing more than a few low houses along hollow sandtracks and a sandy square. The brick-red walls of the first houses are framed with white painted lines. Here and there I see low gates, painted green, or high metal doors assembled from recycled flattened bins. Mostly, the irregular mud walls are framed around sturdy wooden doors, topped by rooftiles and some thatch. Sounds come from behind, children's cries or games, women's voices, animals shuffling. Narrow slabs of pinkish sandstone are wedged in the ground between the farmhouses. Carried over the highways from the quarries of Sur Sagar, in the northwest area of Jodhpur, the tall strips of stone are used in their crude form, fencing off enclosures or separating one mudhouse from the next. Nothing is more than basic in this village. But it all depends on one's perspective. There is a wealth of beauty in these humble lives.

A potter who lives with his family on the edge of the village rolls out the round stone, which I mistook for a grinding wheel, to show me how he works. He carefully stands it on a tiny point of hardwood. He makes it turn by hand. Crouching next to it for hours, he makes water pots, all kinds of roof tiles and even smoking pipes. The clay has been mixed with cow dung to give it elasticity and strength. The *matkas*, water pots, are first shaped like bowls on the wheel, to be somehow moulded to their much larger size, to a thin, metal-sounding texture. *Matka* also is used as a musical instrument to create a perfect imitation of a bird's call. Similar to the firing process of bricks, a wide hole is dug in the ground of the courtyard, filled with layers of straw and wood between the earthenware, covered with earth and made to smoulder.

Adobe houses, as the mud constructions are often called, have to be maintained constantly. There is not enough rain in Rajasthan, but even so cracks have to be filled and floors covered regularly with a fresh layer of cow dung mixed with clay and sometimes finely ground bricks. Cow dung is widely used as fuel and can be seen drying everywhere in round cakes for that purpose. Its disinfectant and insect-repellent properties keep these simple houses very clean. In some areas the

walls are covered with designs. These *mandana* are passed on from one generation to the next, tribal designs, images of flowers, peacocks, a wedding, intricate line drawings... Some symbols on the walls have a definite protecting purpose: hands can be drawn against the evil eye, or the red brought back from the temple on the palm of the hand is applied on the wall near the door as a blessing.

In spite of the scarcity of trees in arid regions, the best roofs on huts and houses are made with wood constructions and thatch like those of the *joompas* in the area of Jaisalmer. The wood comes often from the *akada* tree, toxic for termites and other insects. Rope is used to tie the branches together, the knots and twines known by their ancient names. Due to a desire for modernisation, the entire aspect of the villages has changed dramatically in the past ten years. Cement walls and industrial rooftiles are quickly replacing traditional houses. The "dish" of the TV set now commands a place of honour on the flat roofs. Some people, though, are realising that in spite of more upkeep, the old buildings in the desert provide a higher quality of housing, better insulation both to the heat and the cold, and a healthier environment. The essential elements of desert architecture are now being sourced in an attempt to save and restore a knowledge which was being lost fast.

The front doors are decorated with colourful garlands, *torans*, made with embroidered remnants of clothes, and round decorations made with shiny triangles. A young girl shows me the trick. She fetches a box filled with small, empty bags of her father's tobacco, and sews them on a paper. This is what I love here: the ability to re-use everything. Before I leave, my new friend ties a soft bracelet around my wrist: red wool, cowrie shells, gold tinsel; it is called a *raki*. "We are now sisters," she says, looking me deep in the eyes.

Following double pages:
❀ Dungarpur village, Pali district / the borders of the village, stone fences / the potter's quarters.
❀ Portrait of the potter.
❀ The folds of the potter's turban.
❀ A street in Junia with *mandana* wall paintings.
❀ Thatched roofs and branch constructions, a gate.
❀ Roof tiles.
❀ Two little boys in front of their mud house.
❀ Sounds of laughter in the street near the front door.
❀ Green wall with hands / entrance to a *haveli* house, Shekawati area.
❀ Old lady with her daughter on their doorstep.
❀ Entrance decorations.

Daily rhythms

My driver Satu has proudly offered to take me to his *dhani*, a cluster of huts surrounded by dry millet fields with lots of female antelopes watched by the beautiful "black buck" male and the occasional *khejri* tree. It seems to be at the end of a long, winding sand-track. "Pauline, watch out!" he says repeatedly, politely pulling me more to the middle as long thorny branches scratch the body of the open jeep. After passing the water tank, where a flock of sheep and a few buffalos are drinking near the shrine to Hanuman, we park at the heart of the village. While I gather my camera gear before stepping out of the car, a young woman comes to peer inside, holding her veil open around her eyes in an amazing way. In this open space there are men around so she cannot go uncovered, but she is not in the least shy. I have seen many more doing the same thing. Purdah still rules here, even more than in the city, and within the homes it makes it easy to distinguish the women who are not daughters of the house – daughters-in-law and visiting ladies – as they are expected to cover their heads and often their entire face in the presence of elders and outsiders. They become very good at doing everything with one hand, since the other is constantly rearranging the falling piece of cloth! But behind their odhni veils they are full of wit and do not miss a single thing.

A curved path leads us to Satu's family home, all the houses on the way belonging to uncles and brothers. Inside lives a complex and insular world. Well protected from the outside, these houses are often inhabited by the broad "joint family" of brothers and their wives living together in their parental home, where cousins are called brothers and sisters, and are brought up as such. The ground plan of village houses is generally quite similar. Behind the gates lie wide courtyards, with some cattle in a corner, surrounded by multipurpose covered spaces. There will always be a place for the family shrine: poster-sized printed images of the gods, little statuettes on a shelf, an oil lamp, and colourful garlands. I once even saw a tiger head. Sleeping is done in different places, on the four-legged *charpoi* beds, made of carved roheda wood, which stand lined up on their sides during the day. Quilts and mattresses are neatly folded together under the lines where clothes are hanging. Piled-up metal trunks with heavy padlocks contain the family treasures.

The different living quarters of the houses are not so easy to define, apart from the very sacred kitchen area where shoes are not allowed, the domain of the women who do the cooking sitting on the floor. A small hollow contains a cooking fire which is fed with branches and cow dung. The pans are made to stand on top of it, resting on clay supports: everything is formed out of clay, the cupboards and shelves too, decorated with reliefs shaped with the fingers as well as cowrie shells, a few beads and little pieces of mirror. Tall round containers, again made of clay, serve as storage for grain and pulses.

I happen to walk into a Bishnoi farm one sunny autumn morning to find that millet is being winnowed. Shaking a grass sieve high over her head for hours, one of the ladies is separating chaff from grain. I also photograph the broom, or *sunbha*, used to clean the floor afterwards. A metal sieve on a wall is one of at least eight *chalnis* used for the selection of different types of grain and dhal. The Bishnoi are vegetarians by principle, and have been known for centuries to protect nature with such dedication that antelopes feel completely secure close to their houses and can be spotted around their hamlets in great numbers. To hunt these spotted deer or black bucks risks punishment by death. Unless there is a tube-well there is only one crop a year, often of millet, and only if there have been enough rains. Harvesting is always done before Diwali, in November, after which the sand regains its ground along with large flocks of game. Millet is a cereal so rich in minerals that it forms an essential part of the diet of the desert. It is often prepared as a flat dark pancake, like a chapatti, baked over the fire, and I always love the slice of warm bread with palm sugar and *ghee*, or clarified butter, offered with a tiny cup of hot sweet tea on a cold morning.

In western Rajasthan a lot of weaving is done at home, right inside the outer wall. The narrow streets reverberate with the clicking sounds of weaving shuttles hitting wood. Striped *pattu* blankets and shawls are woven from camel and sheep wool spun by the women. They are very much needed during the freezing winter nights in the desert. Balls of yarn died in beautiful vegetable colours, or in gaudy, almost fluorescent shades, hang from hooks on the low ceiling. Durry carpets in cotton or wool are made here too, in incredible sizes and quantities, sometimes after some famous interior decorator's designs. The carpets are sent to every corner of the world, but it remains very much a cottage industry. The idea of large carpets has come from the Muslims, in Hindu tradition men and women were never seated on the same piece of cloth. One can still

see a teacher or musician bring his own cushion to sit on. The looms for the blankets are on floor level, and the weaver sits in a hole in the ground with meters of stretched warp running along the wall. The looms for the durries, on the other hand, sometimes are so wide that they stand in the courtyard, shaded from the sun by tarpaulins under which up to five men may be working on one carpet at the same time. There is a kind of spinning done by shepherd men which I have seen recently: one can see them walking their flocks in the fields, a bag hung over their shoulders filled with colourful strips of cloth. Piles of recycled textile are sold by weight for this purpose in local markets. As they walk, a spinning top looking like a kind of hook dangles and turns from their arm, producing a multicoloured string which is later used to make graphic patterned *charpoi* beds. It is a "walking cottage industry" as my friend Swaroop Singhji called it.

Far from the women at work, I meet groups of men smoking together from the chillam pipe, which no matter the hour of the day undoubtedly is filled with more than just tobacco: this bare land has a long connection with opium cultivation. These men could also be taking part in the traditional opium ceremony. The dried milk of the poppy pods is strained with water through a conical camel-wool filter, under the watchful eye of the gods on the wall. Some of the filtered liquid is always shared with Shiva, whose effigy as a hooded snake is present on the altar-like stand holding the filters. The brown and slightly bitter liquid is offered by the eldest and most respected man present, from the palm of his hand, to the other participants. This ritual accompanies any special event. On our way back in the warm, low light of dusk through the village of Mandawas, we find ourselves in the middle of a crowd: it is the twelfth day after a funeral, the last day of mourning. Hundreds of men are sitting on striped red and black durries under *shamiana* canopies having opium. They invite me to see a meal being prepared for them outside in enormous karhai pans over fires dug in the ground; long wooden spoons the size of garden spades are used to stir the dhal and the sweet *lapsi* dessert. Out of the ashes come endless quantities of bread balls, the traditional Rajasthani batti dish which can be easily broken into thousands of pieces and sprinkled with *ghee*. The women, meanwhile, are surrounding a young bride hidden inside a nearby farm with an extensive dowry: a wedding will take place after dark, marking the end of this sad time with an auspicious event. She is only twelve, has not yet met her husband-to-be, and will remain with her family for some years more.

Far less dramatic is the marriage rite I happen to come across soon after in another village: preceded by the sounds of drum and a *thali* metal dish, under a canopy simply formed by a veil, a lovely bride-to-be is approaching. The ladies of the family start to dance, one after the other, a serious expression on their faces, in front of the family home, the walls of which have been painted with fresh designs of peacocks and flowers. A vast audience of chatting women and giggling children watch. The bride's glowing face has been covered with fancy little glass bindi decorations. A last hand is being put to her bright wedding clothes as well as to a glittering set of *maudh* head adornments to be worn by both bride and groom during the final ceremony. A few days later I meet her again at the water place of another village, her wedding henna still visible on her hands, proud in her beautiful new clothes, carrying all her jewellery but with her face hidden from view.

Following double pages:
❋ *Purdah* within the home.
❋ Farmhouse with *mandana* paintings.
❋ Opium ceremony inside the farmhouse.
❋ An assembly of men: the last day of mourning.
❋ A village wedding.
❋ Young women at the well.
❋ Winnowing millet in a Bishnoi *dhani*.
❋ A grain sieve on a wall.
❋ A turban hanging to dry, two old men drink water and chat.
❋ Old ways versus modern time.
❋ Bishnoi woven *charpoi*.
❋ Two children on a winter morning with a *pattu* blanket.
❋ Durry weavers.
❋ Desert blanket weavers.

Shopping in the village

There is a bend in the road to the fort at Rohet. From the highway onwards, the whole length of the main street of the village is lined with shops, some of them apparently only used by specific village communities. High steps to reach them are shaded by diverse variations on the improvised awning. I've never seen the substantial rains for which these raised platforms must have been built, but during most of the year the sun is what everybody is trying to avoid. Some kind of garland is always hanging over the shop's entrance, mango leaves or just a few threaded limes with chilies for good luck – or good business? – like the embroidered *torans* hanging over the front doors of houses. On a shelf, lit by an oil lamp or a coloured light bulb, one finds a small altar with a burning stick of incense to Lakshmi, Ganesh, or another favourite god.

Hidden by the bustle of village rush-hour, I make myself comfortable on the top step of one of the small general stores. It sells everything from brushes to beads to groceries, stands in a curve on the only shopping street, and is to be my vantage point for a full hour around five on an afternoon. All motorised traffic is forced almost to a standstill to avoid crossing people, pigs, goats and dogs. Impatient honking, so usual it hardly makes an impression. Wrapping everything in clouds of dust, if not exhaust fumes, the procession on wheels goes on almost uninterrupted: battered jeeps, old rusty tractors as well as flashy new models, sturdy bicycles, open carts transporting full loads of field-workers, roaring motorcycles. Not in the least impressed are the many wide-skirted women going about their business, legs and arms heavy with silver, the incarnation of colour. Old men walk in neat *dhoti* loincloths, light filtering through the folds of white cotton. Conversations go on from one side of the street to the other, with comments on the *Memsahib*, now that I have been found out. And of course, like everywhere, lots of children begin to climb over me. I distribute one kilogram of candy, bought on the spot, while trying to concentrate on the unfolding scene.

The metalware shops are doing good business, there are at least four of them close by. One can order steel boxes made to size for any content imaginable. It is the only way to keep insects out and I have seen piles of them in the farmhouses, painted in different colours. There are endless variations of brass buckets, flat bronze *tambera* vessels used for the bath as well as for dyeing, and

piles of little *sigri* coal stoves. It is sad to see how fast bell metal objects are now being replaced by aluminum, losing the healing properties of a nobler metal only to replace it with one that's poisonous when heated. Like plastic, called by some India's number-one friend and by others its major enemy, aluminum is lightweight, inexpensive and tempting. Nevertheless, these shops are also treasure troves for small cast objects, lamps, small sets of flat brass bells used in pairs by the musicians and in temples, flasks for holy water, incense burners and tiny religious images.

Mulchand Sunar, the silversmith, stops working in order to open all the locked display cases for me. His workshop is right over the street, fire and all, filled by his customers who sit and gossip while waiting for some repair or alteration to be done. His collection of amulets representing various local deities seems to be bought by everybody around; hardly anyone goes without the protective presence of a holy image. He beats the flat silver pendants with sheets of very pure silver on moulds of harder metal. A little snake represents Gogaji, the snake god who was killed by one and thus protects against them; the row of little people symbolises different stories about the "seven sisters", and there are all kinds of heroes on horseback who one finds also on carved stones all over Rajasthan.

After having often secretly taken photographs of passing women's feet, I want to hear more on silver ankle bands. They are known by specific names. The large polished ankle bangle with a round flat lock called a *kadya*, entirely solid silver, is worn by the shepherd or raika women all life long and is only removed after death. Tinkling ankle chains are never worn by widows. Toe rings too, are associated with marriage status. As social distinctions are vanishing, the goldsmith who traditionally worked only with gold, and only for the upper crust of society, is now often working in silver. Mulchand tells me that *Kundun* is the name for the purest form of gold, which is obtained by heating it to such a point that no impurities are left. This deep yellow gold is the most appreciated in Indian jewellery. There is a lovely adage which says that the more one goes through fire – or difficulties in life – the more one becomes "kundun".

The *attar wallah*, the perfume-seller, carries his cut glass bottles in a large wooden box. The essences come mostly from Rajasthan, the mixed scents are secret recipes which are passed on from father to son. While introducing me to the world of perfumes, Kailash rolls little fluffs of cotton wool around thin sticks which he will use as testers. He teaches me how natural perfumes, attar, are always based on sandalwood oil, they "have weight" as he says, last longer and are expensive. This is as

opposed to artificial perfumes, which are based on spirit, are cheaper, and don't last very long. Rose from Ajmer, jasmin, geranium, lotus, lemon oil and vetyver (once seen written as Wait-T-Wait!), a grass root from Sawai Madhopur called *khus* in Hindi, are the ingredients mixed specially for the clients. The Jaipur kings used to have their own perfume department – the *Khusbukhana* - in the palace where special glass bottles were also blown in all kinds of shapes for this purpose. The names of the perfumes are as exotic as their odours. One drop of *Shabnam* on a page of my journal has not lost its strength to this day, while I'll always keep the tiny bottles of Pachouli-Amber and Nine-Flower wrapped in their original cottonwool.

Tobacco seems not to have been introduced until the time of the Moghul emperor Jahangir, but was soon to be widely mixed with the locally grown opium as well as hashish. I have been told with a twinkle that the word "assassin" comes from *Hashashin* in Arabic and that marauding Ismailis in the area used to ceremoniously smoke hashish before setting off to plunder and murder! Large dry tobacco leaves can be found lining the walls of special tobacco shops in the bazaar of most Rajasthani cities, as well as piles of decorative metal boxes containing the ground stuff. *Bidis*, the cheap cigarettes with their diversity of wraps and often mock tobacco, can be bought in the tiniest village shop, sometimes individually. Terracotta pipes are also widely used, and the way the chillam pipe is held, and sometimes shared along with the same piece of cloth acting as a filter, with or without narcotic additions, never ceases to intrigue me. Contrary to men, I hardly ever saw a woman smoke, and I am rather proud of the picture I was able to take of this unusual sight!

It surprises me to see how important the role of food is in a region where fresh foodstuffs are relatively scarce. There is an excellent traditional cuisine in which grilled meat, breads, and sweet desserts play an important role. Recipes for summers and others for cold weather are supported by a long tradition of distinguishing between cooling or warming spices and herbs. Everybody seems to know the best combinations of ingredients as well as what is good for health. For example, the squashed bitter leaves of the *neem* tree are eaten for three days in spring to guard against malaria. My hostess, a dedicated cook who has published two cookery books, always takes great care to have me taste as many different dishes as she can think of during my longer stays. Then one day she asks me if I would be willing to prepare Western food for a dinner party. How many guests were to be expected? About a hundred! Happy occasions are generously shared. Doing this with the help of

a Rajasthani cook who hardly spoke English, without most of the ingredients I am used to, no oven, constant power cuts, and forty degrees of heat has been an unforgettable experience. For large festive occasions in the Rajasthan countryside, sweet *ghewar* is prepared in wide pans filled with boiling ghee, large round granulated cakes soaked in sugar syrup, and many other desserts based on milk, rice, wheat and sugar which can serve large crowds. In the bazaar, towers of something looking like spaghetti are in fact another sweet dish called *sewas*. Round glazed sweet *Misri ki roti* biscuits have been baked specially for me and decorated with flowery saffron designs.

Obviously where there is well-managed irrigation, every herb and vegetable will grow, so green patches are not uncommon in an otherwise extremely dry landscape. Larger villages generally provide a choice of fresh vegetables and fruit. Even where there is a shortage of everything, there is always millet and pulses, used daily. *Ber*, a sort of little plum, is an important part of the diet of the *rabari*, nomad shepherds. There also is a funny little melon called *kachari* which dries to look like a fossil. It is a souring agent for barbecued meat and cannot be cultivated. And the desert provides extraordinary vegetables like *sangari*, used in *panch kuntho*, a vegetable dish. This berry of the *khejri* tree, whose roots can grow thirty meters into the earth in search for water, feeds both man and his animals. Someone once told me: "We in Rajasthan make a vegetable out of everything!"

Following double pages:
❁ An hour in the shopping street at Rohet.
❁ Village shops.
❁ Metalware shops.
❁ Modern times: taps and plastic chairs.
❁ A girl / a man sleeping in front of his shop.
❁ The *chandi wallah,* or silversmith.
❁ The *attar wallah,* the perfume seller.
❁ Tobacco and *bidi* cigarettes.
❁ Vegetables and sweets.
❁ The cobbler and Rajasthani *juties* shoes / funky sunglasses on shepherd dancers.

BRIGHT ENGINEERING WORKS
de Mark Regd. No. 704427 date 11/4/96

Bangles
&
Manufacturers

Manufacturers, Wholeseller, Exporters, Dealer :
y Lac Bangles, Metal Bangles, Plastic Bangles
ancy Meena Jewellery, Handicrafts Items &
another Fancy Novelties

ક્રિષ્ના હેન્ડીક્રાફ્ટ
પેક્ટીંગ વખતે વજન ૩૫ ગ્રામ
ક્રિમત શ. ૮-૦૦

ઙ્લ્મ્પુર્ની સુગ'ધ

533362 (R) ☎ 563270 P. P.
NNA **ETTAR WALA**
PERFUME CENTRE
For All Kinds of :
INDIAN NATURAL FLOWER ATTAR
Baiji Ka Khanda, Manak Chowk Chouper,
JAIPUR-302 003
Rose, Keora, Khus, Hina, Musk-Amber, Jasmin,
habnam, Pachoole Opium Amber-Solid, Nine Flower,
ranium, Way-T Wait Lotus, Firdaus, Sandal-wood Oil,
Oil, Vanilla Kasmir-Flower, Rose Water,
and Best Incense Stick

Barmer Embroidery

फोन 411854 (घर)
मोहनलाल छगनसिंह पटवा
जडियों की ग्राल, घण्टाघर,

Chhipa Yunush
DYEING & PRINTING &
GHAGHRA

भामोरिया मूर्ति आर्ट
प्रो० गणेशनारायण रामप्रकाश
खजाने वालों का रास्ता, बिहारीजी के
मंदिर के नीचे, जयपुर-१
संगमरमर की पत्थर की मूर्तियों के निर्माता

Seasonal fairs

The world has been heavily shaken, but in spite of pessimistic comments about new dangers for travellers, I go to India once again and find this part of the world much at peace. Cohabitation of different faiths carries on as it has for centuries. During this month of November, the absence of tourist crowds grants me unexpected ease to travel and take photographs. Among the festivities which make a brief autumn so colourful in Rajasthan is the world-famous annual Pushkar fair, which is one of those linked to the cattle markets. There are hundreds of such fairs in Rajasthan, often smaller, but always happy gatherings. They are frequently accompanied by dance contests, the intricate steps of the *gher* dances performed by groups of shepherds. With sticks in hand and ankles full of bells, they imitate fights and duels to the trance-inducing rhythms of a drum and a metal *thali* dish. Because of the fun, the excitement and the colour, for me these are days full of surprises.

Together with the fairs come a host of interesting things to buy. For a large part of the population who do not live in cities these are good places for shopping. Next to the cobblers, tattoo artists, clothes, bangles, and other toys and trinkets, there will often be ironmongers, saddle makers, knives, swords, utensils and equipment, and all kinds of ropes and tassels for the animals … Women flock together engaging in tough bargaining with the sellers, while also organising matches for their offspring. Men buy beautiful *gorbandh* decorations for their camels, made of bright woollen thread, cowrie shells, beads, etc; there are also coloured tassels, ropes, and bells for the other animals. New bamboo sticks are selected with great concentration. Jumping and swirling, shepherds in the fields will practice their dexterity with them for the upcoming *gher* dances. Sometimes embellished with metal foil or fire designs, these sticks are also used for many other purposes.

Flat stones with carved figures on horseback can be seen standing everywhere close to the roads in the countryside. They commemorate the courageous deeds of real men and women who lived a heroic life and died under legendary circumstances; sometimes it is a *sati* stone (a *sati* is a widow who died on the funeral pyre next to her deceased husband and has thus reached sainthood). Even in towns, amulets and pieces of coloured thread can be found hanging in a tree over a sacred spot which has been known as such for as long as can be remembered. They are offered for a favour requested

or granted by gods with such names as Bhomeaji, Ketalaji, Gogaji, Behru or Ram Dev. People passing by bend in a quick salutation with the hand to the heart; a driver may slow down and honk.

Each year around April, on the dry bed of the Luni river at Chetri in southwest Rajasthan, the Tilwara fair is held during a week. The exact dates of the annual event are fixed by priests according to the lunar calendar, and thousands of horses, camels, sheep, cows, and donkeys are driven on the roads in advance to this huge cattle market. The flat stretch of sand is considerable and one gets a good view of the tented camp from the riverbank where a small temple has been dedicated to Mallinath, a fourteenth-century prince Rathore who was later sanctified. Every participant goes to this shrine on arrival as well as by the end of the week, to pay respect to the god who grants the place with a yearly miracle. The river is empty of water apart from a small polluted rivulet. But as soon as the flag is hoisted at the shrine and the first prayers have been held, sweet water is found five feet deep all over the camp. Hundreds of temporary wells are dug, and most animals are so calm that they hardy need to be attached, their rope just buried in the sand. This is a sacred place even if heavy bargaining is done over the animals and a lot of card-playing goes on too.

When I have the chance to see this amazing site dust devils are swirling between the tents, lifting straw and papers like little kites. It is very much a men's affair, enduring hardship next to their animals. The heat, unbearable, reaches forty-five degrees. Horses are appraised under the shade of tents next to the *charpoi* beds of their owners. I hear fantastic stories from the men who have come here to look for, more than anything else, the famous local Malani horses. They believe in ancient wisdom and handle the animals accordingly. "It is not the size of the dog that matters, it is the size of the fight in the dog," is one of the things they tell me while looking carefully at a potential acquisition. This phrase is used to judge character in man or animal alike! To check if a mare is in foal, water should be sprinkled on her four hooves: if she shrugs it's a sure sign…! The place is spellbinding. When after eight days the last religious ceremony has been held at the shrine and the flag comes down, all the water is gone.

The small village of Chotila is the site of the annual commemoration of a sufi saint called Dulesha. It is more than an hour's drive by jeep over sandtracks lined by thorny acacia bushes and tall cactus, jumping antelopes, peacocks, a mongoose if one is lucky, and the occasional 'blue bull' spotted in the open stretches. I am accompanied by five local men who feel very responsible for me.

As far as I understand, this is a Muslim festival, attended by many Hindus. We announce ourselves at the makeshift police tent before starting to walk around. I find myself in the middle of a huge fair, the whole scene blurred by a mist of dust. Three enormous ferris wheels, visible from afar, tower over the grounds where thousands of people camp for days under wide canopies, entertained by an old-fashioned circus, carnival mirrors and other attractions, soothsayers, food stalls and candyfloss sellers. Prayers and offerings are performed day and night, together with the singing of religious sufi *kawali* songs, on the shrine of a holy man whose story I am unable to gather. While we walk around I am told of many wondrous deeds covering far more than one lifetime…who was this Pir Dulesha or Nanushah?

Before driving back, we go to see the man who can give me the answers, the lord of the place. This colourful gentleman is famous for, among other things, his hospitality in feeding at every meal as many people as happen to be there, sometimes up to sixty. The women of the family are kept very busy indeed! I find myself seated in the courtyard of what was once a palace, a huge carved gate and heavy doors the only witnesses to a grand past. Cows are coming home after a day of grazing while dogs go in and out, chased by strings of children. The friendly and much-respected Thakur Sahib offers me tea and starts an enthusiastic description of the brave man who gave his life many centuries ago. I had not realised that he spoke only Rajasthani, and he wonders why I am not writing… Within minutes the headmaster of the village school is fetched and sits down to take a steady dictation! I watch with growing astonishment, carried on the waves of the voice of my host, the shuffling of animals close by, the muffled laughs of twelve children sitting on a low wall, while the sun sets and the sky turns from steel blue to green to indigo with more and more planets and stars turning into constellations. The loudspeakers of the local Hindu temple, in retaliation against the little mosque's recorded muezzin, have long ago finished shouting a Hindi pop version of evening prayers. Sheet after sheet of paper is filled on both sides with neat lines of Hindi script. After more than two hours my driver tells me that we really should go, worried about finding his way back through the desert in the dark. Fourteen pages are pinned together while we take our leave and I return home feeling rich with this coded treasure. When I wake up the next morning, eager to bother a willing friend at length for the necessary translation, I find that yet another set of tightly written pages has been brought for me from the distant village…

Centuries ago Pir Dulesha, or Nanu Shah, a Muslim, was leading his camel caravan from Bombay to the north for his commerce of dry fruits. In the area of Chotila they stopped for breakfast with Hindu *raika* shepherds (from whom comes the connection with the many Hindu pilgrims). Later that day they met with the family of a goldsmith bridegroom, who was accompanying him on his way to his bride, and were offered a share in the meal that was being prepared. It was then that bandits, who had hidden nearby knowing of the amount of gold which was transported as a dowry for the wedding, attacked the gathering. In the fight that followed Nanu lost his life and was buried on the spot. When the same caravan passed Chotila a year later, they tried to open the grave, intent on giving Nanu a better grave back home. But they found it empty and the man's voice was heard from its depth asking to be left where he was. That is why a tomb was erected for him in this middle of nowhere. From that time on miracles were reported, many within the Hindu shepherd community, of cattle that had been ill and recovered and of people whose lives had been saved. Nanu was called "shah" by the Muslims, standing for a martyr who appears to someone else in a trance. *Pir* is the Hindi equivalent of shah, and as Nanu gave his life for a *dulla* or groom, the Hindu call him Pir Dulesha. Most places of pilgrimage have grown in a similar way, often worshipped by different faiths.

Magic and stories are the lining of life in harsh conditions. An indefinable and incredibly colourful charm has not ceased to draw me back to Rajasthan.

Following double pages:
❁ The red dresses of communities near Barmer.
❁ What do women buy at a local fair that they can't get in a village?
❁ White sugar toys and white *patasha* sweets for Diwali, the autumn festival of lights.
❁ Ferris wheels at the Chotila fair, November 2001.
❁ Tilwara fair at Chetri, April 2000, hundreds of tents for a week.
❁ Camel races at Chetri and *gorbandh* camel decorations.
❁ Gathering of men with the women in the back, Kothani fair, March 2000.
❁ Gher dance competition at Kothani and a collection of *bidi* cigarette wraps.
❁ Cattle market at Sawai Madhopur, January 1999.
❁ What do men buy? Sticks!
❁ Evening over the grounds at Chetri.
❁ Camels on the roads after the cattle fair.
❁ Wall painting with horse and rider.
❁ Sati shrine under a tree.
❁ The fierce god Behru on a rock in Jodhpur.

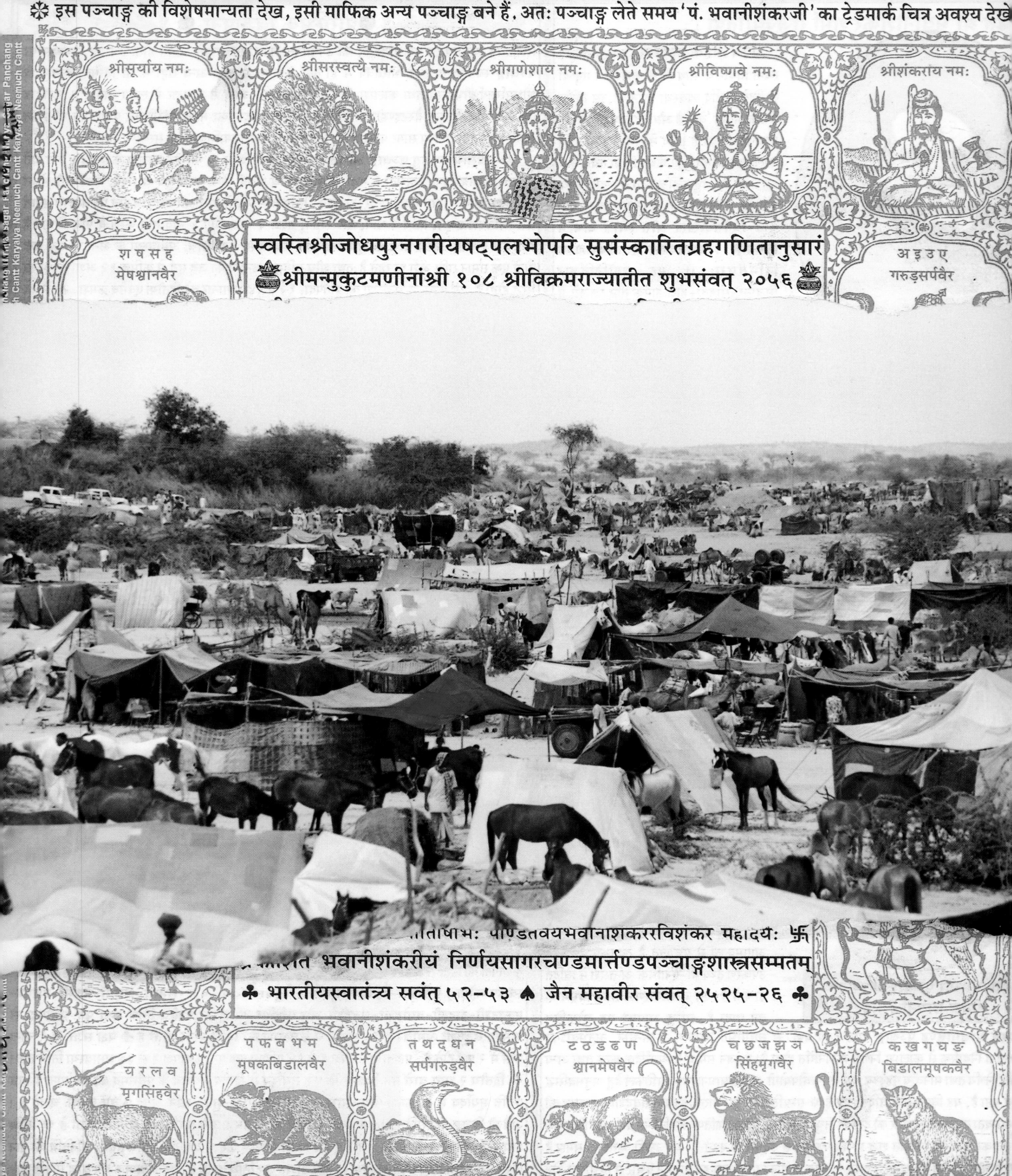

श्रीसूर्याय नम: श्रीसरस्वत्यै नम: श्रीगणेशाय नम: श्रीविष्णवे नम: श्रीशंकराय नम:

श ष स ह
मेषश्वानवैर

स्वस्तिश्रीजोधपुरनगरीयषट्पलभोपरि सुसंस्कारितग्रहगणितानुसारं
श्रीमन्मुकुटमणीनांश्री १०८ श्रीविक्रमराज्यातीत शुभसंवत् २०५६

अ इ उ ए
गरुड़सर्पवैर

...तिथाभः पण्डितवर्यभवानीशंकररविशंकर महादयः ❋
...सारित भवानीशंकरीयं निर्णयसागरचण्डमार्त्तण्डपञ्चाङ्गशास्त्रसम्मतम्
♣ भारतीयस्वातंत्र्य संवत् ५२-५३ ♠ जैन महावीर संवत् २५२५-२६ ♣

प फ ब भ म
मूषकबिडालवैर

त थ द ध न
सर्पगरुड़वैर

ट ठ ड ढ ण
श्वानमेषवैर

च छ ज झ ञ
सिंहमृगवैर

क ख ग घ ङ
बिडालमूषकवैर

य र ल व
मृगसिंहवैर

Acknowledgements

How did I come to do this book? The answer is largely thanks to others. I am continuously amazed at the way things happen. My first acquaintance with India came out of chance, an invitation to join a small group of friends, and the spontaneous support of my father and my husband. Their openness to things new is, and was, the key to my doing, and Berndt, even if sometimes a little bowled-over by my way of tackling the adventures as they are starting, has stayed in the background while steadily being a safe haven. Paul Berndt and Vanessa, my now-grown children, should read here how important their critical eye will always be to me. Together with their father, they form my jury and my fan club. Vanessa allows me to share her writer's experience, while Paul Berndt casually makes a remark on layout or leaves a sample of colour while walking through my studio.

I will always remember with fondness my first tour in India with Lance and Cila Huët in 1988. It was only the beginning of years full of travel during which my family were often embraced by faithful neighbours and friends whose hospitality never failed as time went by, and whom I may not have told often enough what a difference that made.

Finding a shape for what was becoming a book has been like a voyage too, as I encountered seemingly dry technicalities, and was met with skepticism. According to some, the computer had become the only acceptable tool, and my use of scalpel and scissors seemed bound to fail. The two great exceptions were Frederik de Wal and Irene Weisberg. The first, in spite of his skills as a graphic designer, or maybe because of them, repeatedly encouraged me to do my own thing. The latter, like a lifeline, responded almost daily to my questions over email, and introduced me to writing. With their encouragement I dared walk into the unfamiliar world of publishers! And if it has perhaps taken some time for me to realise the dedication of Ronald Beduel and H. Pepermans at processing my photographs, my work largely depended on the quality of their prints. Later on, the editing of my English text could not have been in better hands than in those of Andrea Smith, based as it was on her experience as well as her friendship.

At the heart of this book is my link with India. I wish to thank particularly His Highness Gajsingh II Maharaja of Marwar-Jodhpur for his kind foreword. Of course my Indian attachment is very much a living process! It is entirely supported by the people I keep meeting, and there are so many friends whom I would like to thank. Through their hospitality, their suggestions, their stories and enthusiasm, I have found a home in Rajasthan. First of all there will always be the fort at Rohet! Manvendra, Jaya, Siddharth and Rashmi Singh, thank you for even more than you know, and especially your patience with my curiosity while I stayed for weeks on end. My gratitude also goes to the late Maharaj Swaroop Singh and his wife Usha Rani. Among many good memories are the evening fire brought from the temple on the roof of Narlai where you had just taught me a yoga exercise, and Raghu's wedding. Thank you Satu and Chamund Singh for accompanying me and guiding me. And thanks to the people of Rohet. Pawan Khanna, together with his staff at Rainbow Travels in Delhi, sometimes did almost magical tricks to make it all possible, besides always being there to give me sound advice. In Jaipur Kuldeep Singh approached my research with kind efficiency.

More excellent moments are to be found in the images of this book. I have sat many times on the porch at Komal Kothari's, drinking tea while picking his brains for his wide knowledge of folk culture and customs, as he taught me to watch more closely what I was seeing. Every following visit started with a short examination of what I had noticed, after which came his patient explanations and stories. Likewise, I have much appreciated the conversations on art, painting, and ceramics with Kripal Singh Shekawat. And while I had carefully prepared my questions for Mr Yaduendra Sahai at the City Palace in Jaipur, his enthusiasm in return was most helpful. On the chapter of textiles I found great help in Jodhpur with Tayeb Khan, and in Jaipur and Sanganer with Kitty Rae, Vikram Joshi, Bindu Singh Chandela, and Tejinder Singh Sodhi. Special thanks should go to Ratan textiles. Samples of the paper making process in Sanganer were generously given to me by Abu Hassan Kagzi and Alim S. Kagzi. I enjoyed the freedom of taking pictures in their work-shops. For gems and jewellery, treasure troves were opened to me in Jaipur by Munnu Kasliwal, Rajesh Ajmera, and Rajendra Bothra. Abid Sagheir introduced me to Rajasthan's antiques, and I owe him the surprise of Jaipur's Panigaran quarters with the dyers as well as the gold and silver leaf makers. In a similar way the old city of Jodhpur was mapped for me by R.K Singhal and Rameshwar Singhal. Mr J.N. Jopat, Munnu Bothra, and Satu made me street-smart while guiding me. I will always remember standing in front of the X-plain school while I was being admonished: "Madam, any enquiry that you have, please tell me, and if you would now please listen carefully, I will explain…"

In Delhi, my friend Royina Grewal deserves the title of inspirer and safe harbour! Laila Tyabji, how important it was when you showed your agreement with my approach. Jyotindra Jain, the Crafts Museum you created in Delhi is a wonderful place to feel inspired as well as to put one's thoughts in order. Swati Thiyagarajan, from you came the poems and songs I so much hoped to find to enhance my images. And Ravi Sabharwal, thank you for your moral support.

The last chapter of this adventure was spent in Paris. I found far more than hospitality with Hélène de Margerie whose continuous enthusiasm fuels my stays with fun, and who reconnected me with a part of my roots. She may be called the "godmother" of this book. I also wish to count my friends at the librairie 7L, Catherine Kujawski, Hervé le Masson and Vincent Puenpe, as well as Camille Bauer, amongst the fairies who stood at its cradle.

Finally, it is thanks to Lee Stern at Barnes & Noble that I met my publisher. I will never forget a sunny morning on the place Vendôme, when Prosper Assouline seemed to have decided within five minutes to publish my book; he, his wife, Martine, and their team of talented young people have opened to me the side of book making that I, as a bookbinder, did not know. Having been allowed to take part in the process from the beginning through to the end has been a continuous source of pleasure.

The people I have thanked, and the many I regret to have forgotten to mention, have held my hand in their own way and participated in shaping this book. I owe them a large part of what I have been able to do because, to quote Isaac Newton, "If I have seen further, it is by standing on the shoulders of giants".